The Arts of the Hausa

David Heathcote
A Commonwealth Institute Exhibition
World of Islam Festival 1976

World of Islam Festival Publishing Company Ltd

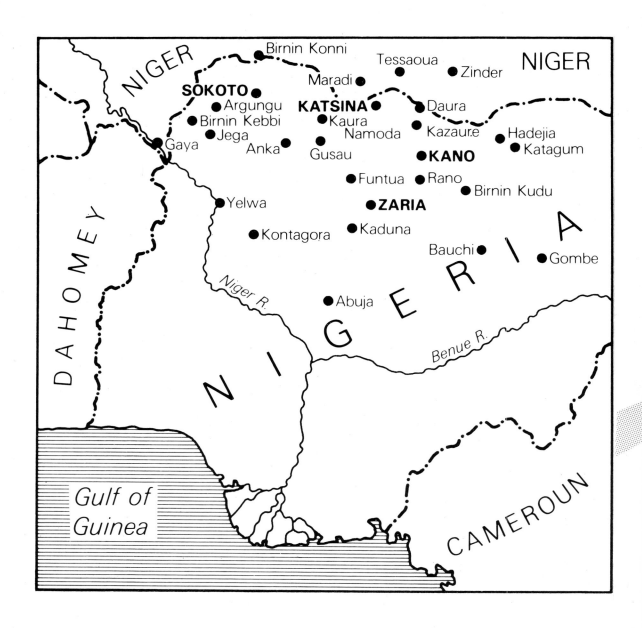

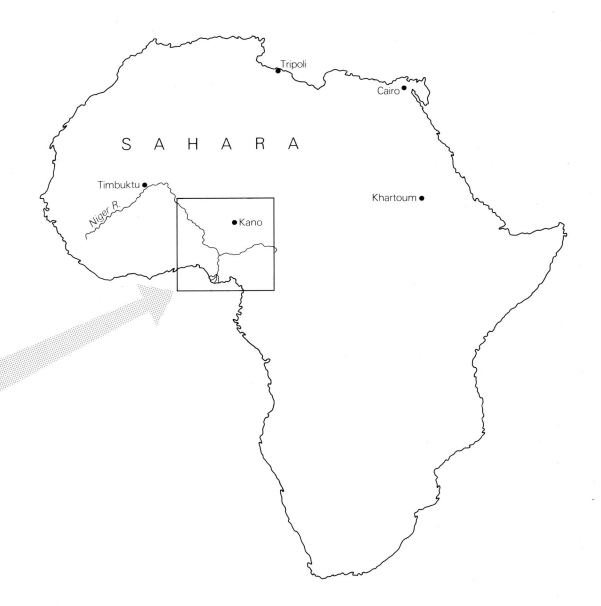

SAHARA

Tripoli

Cairo

Timbuktu

Niger R.

Kano

Khartoum

First published 1976
ISBN 0 905035 05 4

Exhibition research by David Heathcote
Exhibition design by Michael Haynes
Exhibition planning and management by Fred Lightfoot MBE ASIA and Donald Bowen FRSA

Published and produced by the World of Islam Festival Publishing Company Ltd.

Designed by Colin Larkin
Edited by Daphne Buckmaster
Photographs by David Heathcote and John Warren
Set in 10/11pt Monophoto Plantin 110
Printed on 115 gsm Blade coated cartridge

Colour origination: Westerham Press
Filmset by Westerham Press and printed in England by Westerham Press Ltd., Westerham, Kent

Front cover photograph:
Design for a hand-embroidered cap, drawn by a Quranic scholar in Zaria City.

Back cover photograph:
Detail from a basketry fan, from Katsina.

Contents

Acknowledgements

The Hausa exhibition was made possible largely through the assistance of the World of Islam Festival Trust. It is a pleasure to have the opportunity of recording my personal thanks for this, and for the important contribution made by the Commonwealth Institute, which not only provided an excellent gallery but whose staff have so superbly dealt with all the various administrative problems connected with the exhibition. I should also like to express my deep gratitude to Ahmadu Bello University, Zaria, for support that enabled me to complete a rather lengthy period of part-time research in Nigeria. I wish to thank very warmly Alexandra Beale, Donald Bowen, Paul Keeler and Dorothy Morland for their encouragement and help at a time when the exhibition was only a faint possibility, and Michael Haynes for his perceptive and imaginative installation of the material that was eventually assembled for it.

For participation of various kinds, including in several cases the locating of exhibits, I am greatly indebted to the Emir of Kano and the Emir of Zaria, Murray Last, my wife Janet, and a number of colleagues in Zaria, in particular David Ames of the Department of Sociology, Kenneth Gourlay and Wilhelm Seidensticker of the Centre for Nigerian Cultural Studies, and Saidu Na'Allah, Louise Baker, and Diana Leoni of the Department of Fine Art.

Although the future of the material listed in the catalogue is uncertain the owners have agreed that if possible it should be kept together as a single collection.

David Heathcote, Zaria, Nigeria, 1976.

Foreword

To anyone who knows Northern Nigeria well nothing could be more evocative of its life and culture than this exhibition of the arts of the Hausa. The works exhibited here seem to be inspired as much by the clear skies and broad horizons of the province as they are by the influence of the world of Islamic art which, as a cultural continuum extended in space from Asia to Africa and in time for over thirteen centuries, is being exhibited in London in 1976 by the World of Islam Festival.

Over the past few years the Commonwealth Institute has gained a reputation for its exhibitions of embroidery. In May 1974 we were approached by the Secretary of the Embroiderers' Guild with the suggestion that we might be interested in mounting a display of Hausa embroidery. The suggestion was received with enthusiasm. After making contact with David Heathcote, Senior Lecturer in Art History at the Ahmadu Bello University of Zaria, Nigeria, the Institute put it in the programme for 1976. This date soon proved especially appropriate, because in October 1974 the World of Islam Festival Trust proposed to us that the exhibition should be brought within the compass of the festival that it was organizing for April, May and June 1976. The proposal was naturally accepted with pleasure since this sponsorship enabled us to enlarge the scope of the exhibition to include other arts besides embroidery and to keep it on for a longer time. It also ensured that the event would be much more widely known.

The resulting exhibition is a co-operative venture. Those involved are David Heathcote, whose scholarship provided the substance of the exhibition and this catalogue; the Commonwealth Institute, in whose Art Gallery it is mounted, and who also supplied the necessary organization and management; Michael Haynes, the designer, who contributed the imaginative display treatment; and the World of Islam Festival Trust, whose generous support enabled the mounting of a much more professional presentation than could have been managed from Commonwealth Institute resources alone.

But it is the magnificent artistry of the Hausa people that makes this exhibition such a notable and unique event, for this is the very first time that the Hausa have been represented by a major exhibition anywhere in the world. As Chairman of the Board of Governors of the Commonwealth Institute, and as a former Deputy High Commissioner and High Commissioner in Nigeria, I am very proud that we are able to show many aspects of the design and decorative work of this greatly talented people to a wide audience as part of

the World of Islam Festival. I have no doubt that the exhibition will delight all those thousands of people who will see it but, more important, it will surely stimulate a desire to learn more about the Hausa and about Nigeria, that great Commonwealth country which is home to so many of them.

Sir David Hunt, KCMG, OBE
Chairman, Board of Governors,
Commonwealth Institute, London

January 1976

The Hausa and their Arts

The Hausa are one of the largest groups of people in Africa. Most of them live in an extensive area of northern Nigeria, whose outstanding physical characteristics are widely separated, densely populated towns and gently undulating, farmed countryside scattered with trees and hamlets. Apart from the Hausa who live in northern Nigeria, there are others who, mainly through enterprise in the field of trade, or expertise in crafts such as indigo dyeing, have established themselves in neighbouring and also distant parts of Africa: as far west as the Atlantic coast, as far north as the Mediterranean, eastwards throughout the Sudan, and southwards to the Gulf of Guinea.

A number of the early settlements in Hausaland developed where outcrops of rock occur. These are an occasional feature of much of the natural landscape, and some of them are still associated with pre-Islamic beliefs. Initially their attraction was probably that they offered good defensive positions, and that since the ground in their immediate vicinity tends to be moister than in other places, defence could often be combined with better farming conditions, particularly during the long, dry season.

While numerous settlements associated with these outcrops were later abandoned, and others remained small, a few, such as Kano and Zaria, grew into large, walled cities, partly as a result of immigration and trade, and also because they became the centres of a kind of city-state authority. The more extensive Hausa walled settlements enclose dense, mud-built housing, and some contain areas of farmland, which suggests a former state of readiness for times of political instability. Whatever the true causes may have been for this inner-city farmland, it still provides a number of the urban Hausa with convenient land for cultivation.

The Hausa peoples have achieved considerable cultural unity, on the one hand because the Hausa language is everywhere used, and on the other because the Hausa have a way of life that has become increasingly orientated towards Islam. The process of Islamization has been going on for over five centuries and was accelerated in the early nineteenth century when the Fulani, who had come to Hausaland from the west as a nomadic people, set in motion a drastic programme of religious reform, during which they established themselves as a new ruling class. Descendants of these rulers, though their traditional powers have been considerably modified in recent years, still hold positions as emirs today.

The arts of the Hausa are predominantly decorative. They

have grown out of a continuous need for useful commodities such as houses, clothes, utensils and tools, and an appreciation of simple or elaborate, well-made and well-decorated articles of all kinds. The long, dry, season when little farming is possible has been an important element in Hausa artistic development, since it gives many men the time to work at the crafts. Cities such as Kano, Katsina and Zaria, which grew largely as a result of trade, immigration and even the capture of African peoples, came to possess big markets and great wealth, and this encouraged a competitive atmosphere that helped to keep the quality of artistic work high.

It will be clear from the exhibition that considerable outside Islamic influence has been at work. The nature and degree of this influence varies from one kind of product to another, so that objects of foreign Islamic workmanship, such as armour, are used in Hausaland side by side with local products, such as certain types of leatherwork, whose decoration is only partly inspired by foreign examples, and various cloths, pottery and wall decoration that can be considered more truly Hausa.

Hausa art is not, and doubtless never will be, entirely unified or completely distinct from the arts of other Islamic West African peoples, and one can no more talk of pure Hausa art than of pure English art. Yet certain artistic products from Hausaland do qualify for the adjective Hausa while others do not, and in almost every case where I have selected an item for the present exhibition it was on the grounds that, apart from being a good example of its kind, it was something made and used by people who describe themselves, and who would also be described by other West Africans, as Hausa.

The arts of the Islamic peoples of sub-Saharan Africa have yet to receive the recognition they deserve. Unfortunately, it is still often presumed that Islam has been a totally destructive force there, whereas in fact Islam has to a great extent been adopted in a gradual, voluntary process, and indigenous culture has not been entirely denied. It is true that one of the results of Islamization in Hausaland is that representational art, which is today actively discouraged in some areas, has only a limited and recent history, but it is by no means completely absent. Musa Yola has been able to practise extensively in the Zaria area, where his wall decorations have become extremely popular, and many ornamental mud reliefs in the same region, while essentially decorative, also feature recognizable objects, including even human figures. There are other examples of representational work, such as the recent Hausa women's embroidery and the pots occasionally made as part of a girl's dowry. The latter are decorated with birds, and may in addition be brightly painted. Small dolls, furniture, and food bowls, all of baked clay, have for long been made by women in Argungu, and little schematic dolls of dyed Indian hemp stalks and groundnut paste are still manufactured in Kano and Katsina. Though one of the aims of the exhibition has been to promote understanding of the decorative arts of the Hausa, it should perhaps be stressed that a feeling for sculptural form, and even naturalism, is by no means absent in Hausaland. It is also worth pointing out that apart from the kinds of work already mentioned, there is a brisk trade in portrait photography among the Hausa, and a growing number of Hausa art students make sculpture and paint portraits.

The question most frequently asked about Hausa art is whether the designs that are used have any special meaning. The simple answer is that they do not, though separate parts of a pattern may have some significance. For instance, a trader's lorry represented in a decoration on his house is an effective status symbol, as in fact the whole wall may be if it is covered with any sort of decoration. But I have found no evidence of any elaborate symbolism in Hausa art. Though there is a great fondness among the artists for naming individual motifs, the fact that such names are not part of any complicated symbolic scheme is hardly surprising. Many traditional patterns are made up of material derived from various sources and worked into some sort of unity, and the names for the separate parts often appear to have been arrived at quite spontaneously.

The element of spontaneity is also evident in the actual treatment of traditional designs, even where well-known arrangements are being repeated. There is in Hausaland no special concern over neatness in art, so that even where the disposition of the main elements in a design is firmly maintained, details and general appearance often vary. If one were to look for a parallel elsewhere, one could certainly find something in the art of Romanesque Europe, and though apparent similarities in Hausa and Romanesque work should not be over-emphasized, it is nevertheless an interesting parallel, since some of the same Oriental decorative influences, particularly in the form of interlacing ornament, affected the arts of both these cultures.

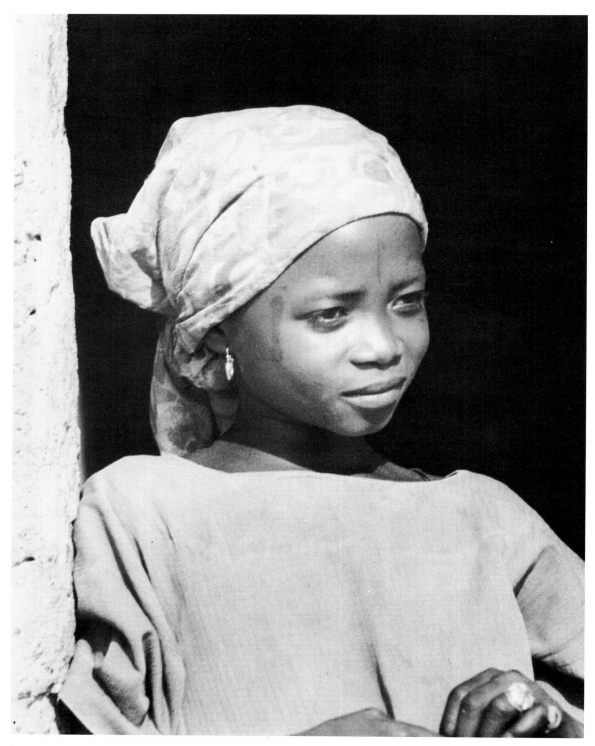

Young girl, called Amina, of Zaria City.

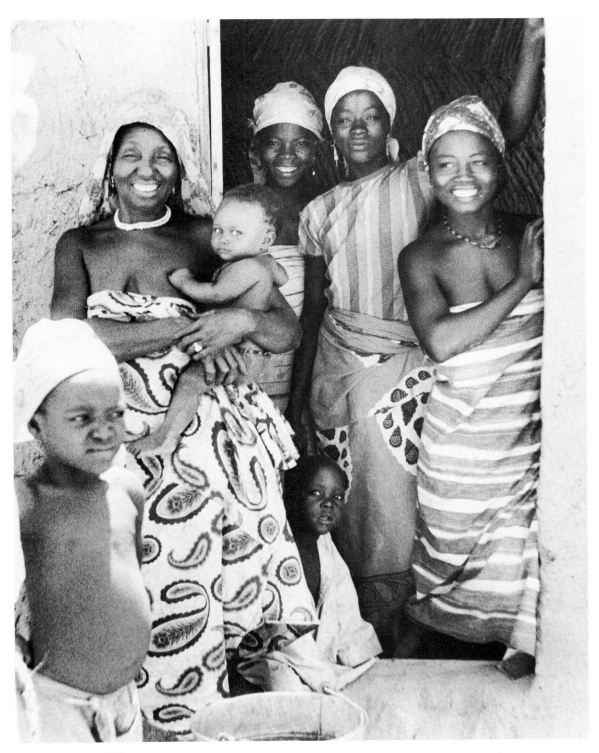

Women in Hunkuyi village.

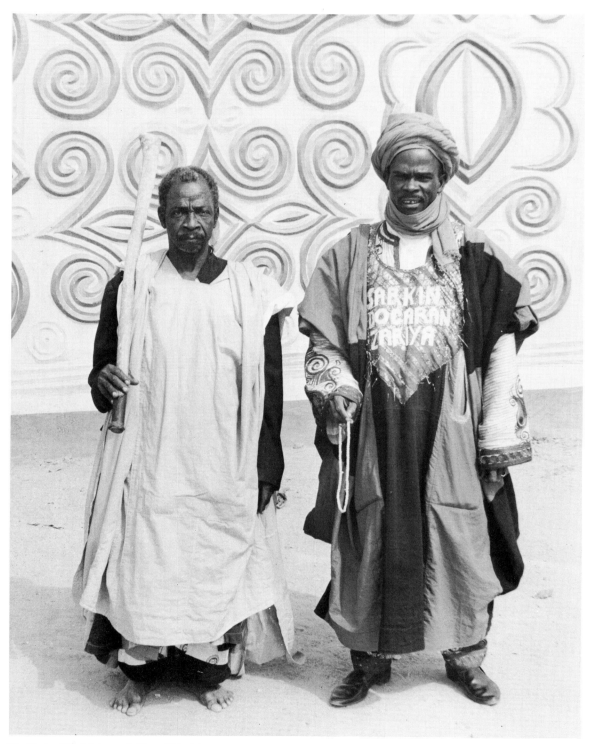

The Emir of Zaria's jester (left), and his chief bodyguard.

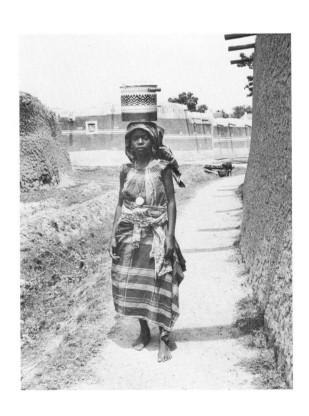

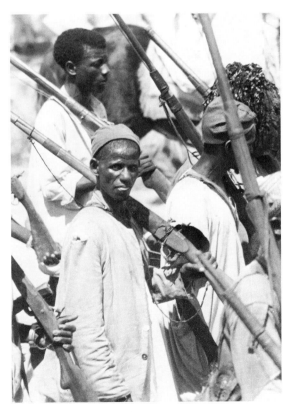

Young girl carrying an enamel food container, Zaria City.

Hunters in a *Salla* procession.

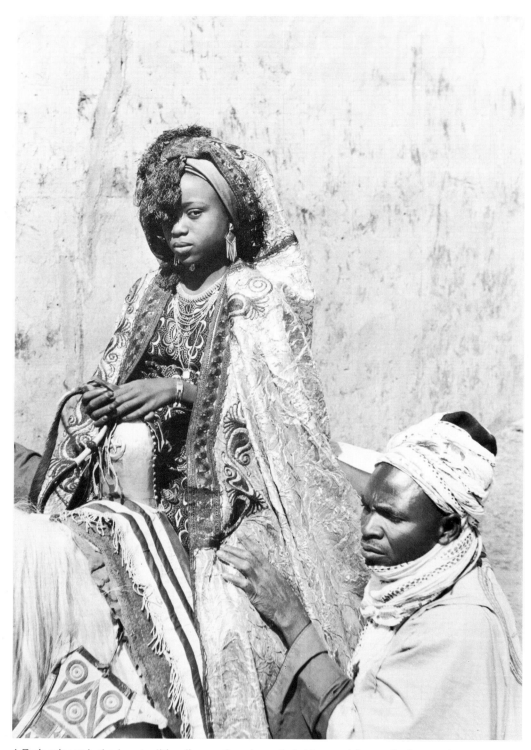

A Zaria princess in the dress traditionally worn for going to the bridegroom's house after her marriage.

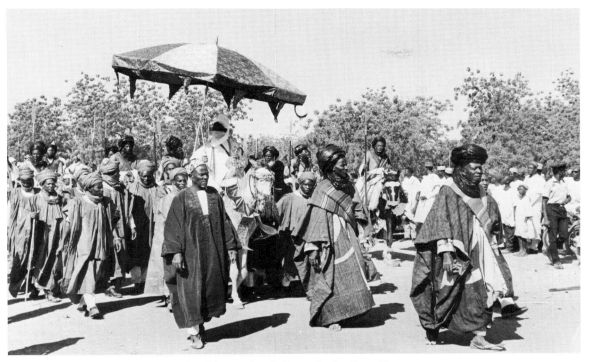

The Emir of Katsina (under the umbrella) taking part in a *Salla* parade after Ramaḍān.

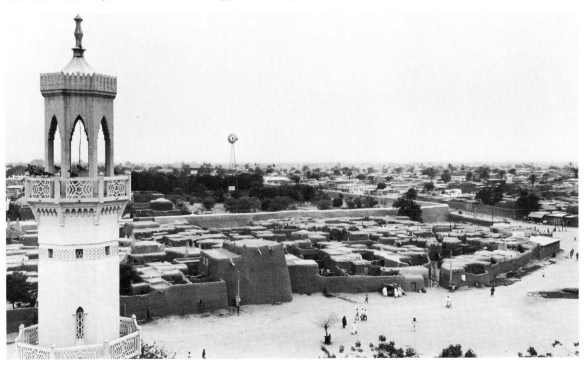

Kano, from the modern mosque.

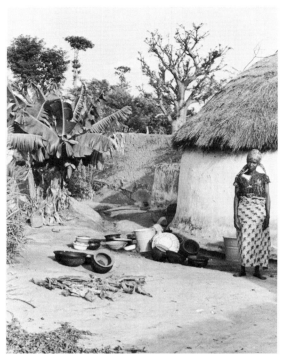

A family compound in the Madaka quarter of Zaria City.

The quarter known as Yelwa, on the outskirts of Kano.

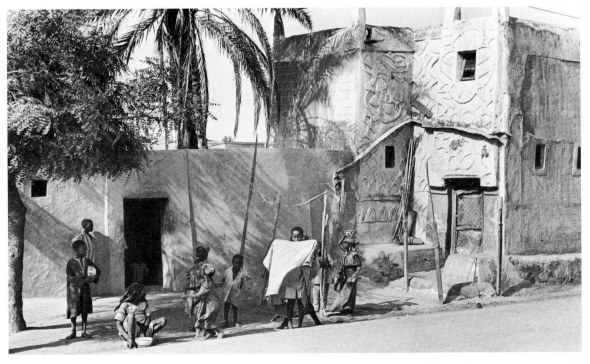

A street near the Emir's Palace, Kano.

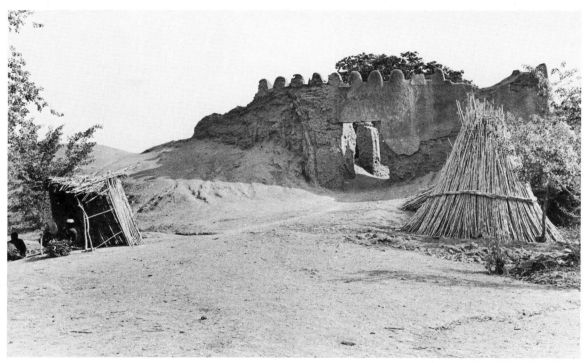

One of the remaining gateways in the walls of Kano City.

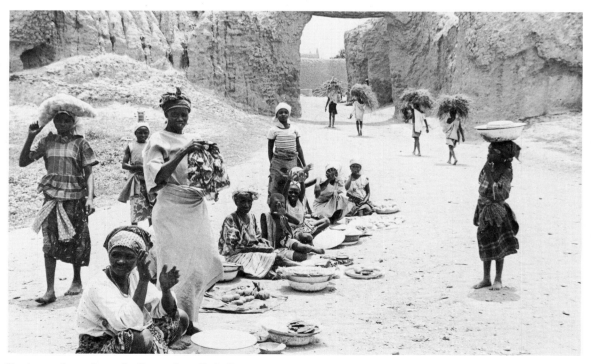

Traders on the road near the Gayam Gate, Zaria City.

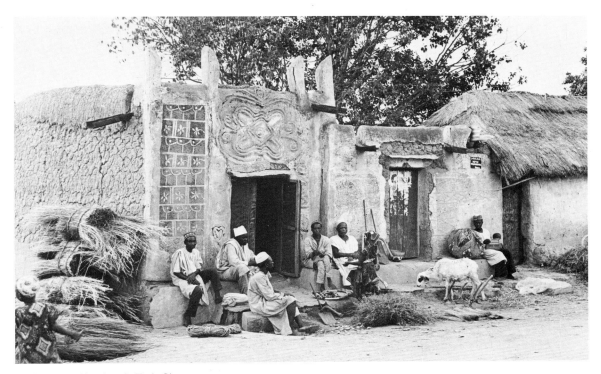

Craftsmen and hawkers in Zaria City.

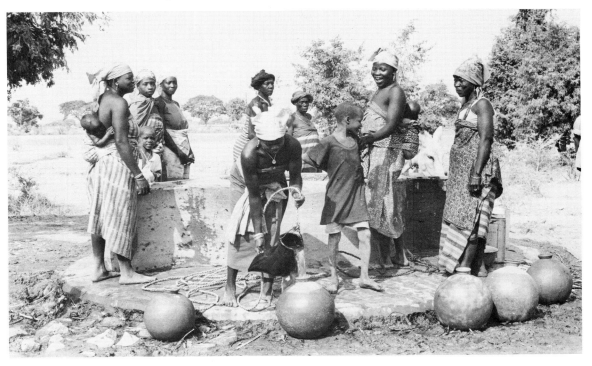

Women at a well near Kura village.

Calligraphy and Drawing

The first form of writing adopted by the Hausa was Arabic, and the copying and memorizing of passages from the Qur'ān is the basis for the formal education of many Hausa children. Quranic teachers in the urban centres take on day pupils, as well as other children, who are sent in from the country districts to lodge with them. Their pupils practise writing on carved, wooden boards, using cornstalk pens and locally made black ink that is kept in small calabashes or pottery ink-wells. Writing boards from which the ink has often been washed to provide a fresh surface become pleasing objects in their own right, even without any writing on them.

When a young pupil has achieved a certain level of instruction, the teacher may send him out with a writing board on which a suitable passage from the Qur'ān is written, and which is often also decorated with a special kind of pattern known as *zayyana*. This the pupil carries about in order to demonstrate his proficiency, in recognition of which he can expect an occasional small gift of money.

Some of the Quranic teachers, besides supervising the formal studies of their pupils, also take a hand in craft work. These men have had a distinct influence on the development of embroidery, and since calligraphy and drawing are closely allied, it is natural that the process in which they have tended to become involved is the drawing out of the patterns before they are sewn. It is at this stage that new designs are initiated, or established patterns elaborated.

There are also, among the less devout of the Quranic scholars, those who use their knowledge and their calligraphic skill to cater for the more superstitious elements in Hausa society. Concerning themselves especially with fortune-telling and the writing of charms they produce among other things muddled versions of Quranic texts and decoration. The charm gown in the exhibition (no. **20**) is an example of this curious kind of work.

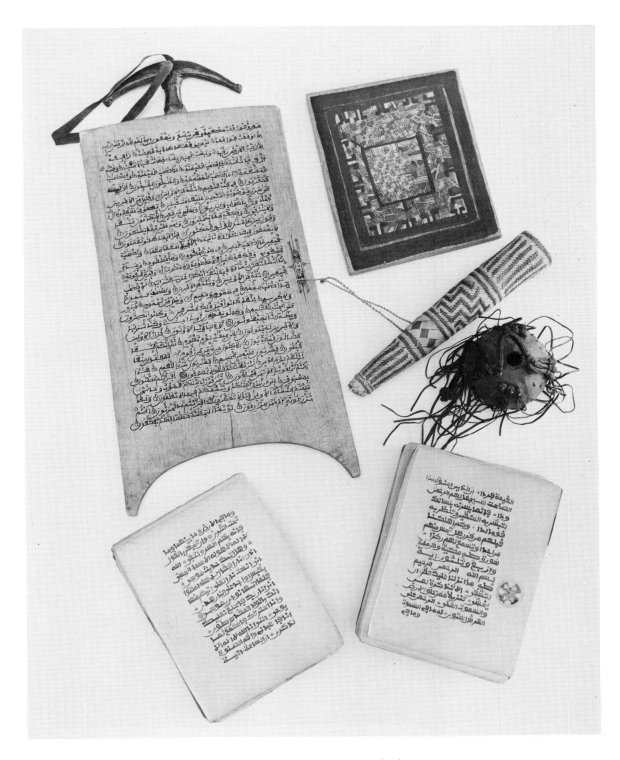

10, 4, 2, 1, 5. Quranic board, *zayyana* decoration, pen case, ink container, and Qur'ān.

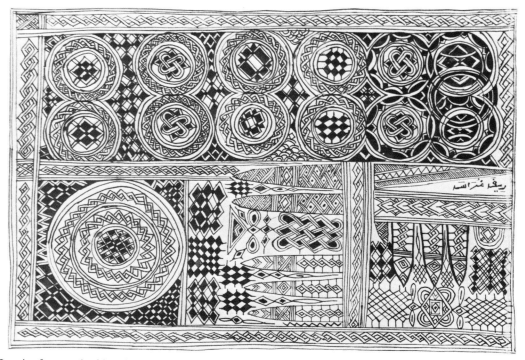

13. Drawing for an embroidery design called *gurasa*.

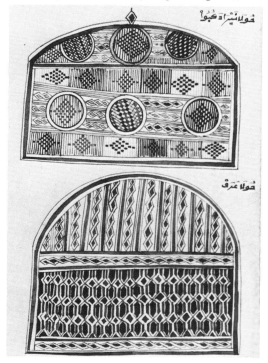

14. Cap designs drawn by a Quranic scholar. Zaria City.

1. Ink pot made from a small gourd, with attachments in plaited leather. Zaria City, 1975. w. 10 cm.
2. Pen case, made from strips of dum-palm fronds by a Hausa Quranic pupil. Zaria City, 1975. l. 30 cm.
3. Wooden writing board, decorated with *zayyana* patterns by a Quranic scholar. Zaria City, 1975. l. 48 cm.
4. Quranic *zayyana* pattern known as *mai gatari* (with axe shapes), drawn on wood. Kano, 1972. l. 24½ cm.
5. Qur'ān. Zaria City, before 1971. l. 24 cm.
6. Decorated leather satchel for a Qur'ān. The circular shapes are referred to as *ido* (eye) and may be connected with earlier symbolism of a protective nature. Made by Alhaji Balarabe, 1971. w. 26 cm.
7. Wooden prayer beads from Mecca, in use in Katsina, 1975. l. 100 cm.
8. Wooden writing board, decorated by Malam Nuhu Mai Shaida. Zaria City, 1971. l. 54 cm.
9. Child's wooden writing board, decorated by a Quranic scholar. Jibiya, 1975. l. 31 cm.
10. Boy's wooden writing board, with a passage from the Qur'ān written by a Quranic scholar. Zaria City, 1975. l. 60 cm.
11. Wooden writing board with a Quranic pattern drawn by a scholar. Jibiya, 1975. l. 55 cm.
12. Drawing by a Quranic scholar, in black ink, of the embroidery pattern called 'two knives'. Zaria City, 1974. h. 29 cm.
13. Drawing by a Quranic scholar, in black ink, of the embroidery called *gurasa*. Zaria City, 1974. h. 30½ cm.
14. Two original designs for embroidered caps, drawn by a Quranic scholar in coloured inks. Zaria City, 1974. h. 29 cm.
15. Two original designs for embroidered caps, drawn by a Quranic scholar in coloured inks. Zaria City, 1974. h. 28½ cm.
16. Drawing in coloured inks of one of the patterns called, singly, *zayyana*, and used for decorating Quranic writing boards. Zaria City, 1974. h. 39 cm.
17. Five ink drawings showing variations of part of the pattern called *malum-malum*. Drawn by Alhaji Sanni. Kano, before 1967. Average h. 20 cm.
18. Ink and ball-point drawing for the embroidery pattern called *'yayin Sharif mai wata*. Drawn by Alhaji Sanni. Kano, 1957–67. h. 78 cm.
19. Preliminary drawing in *karan dafi* ink on cloth for the pocket area of the pattern called 'two knives'. Drawn by Malam Zangina. Zaria City, 1970. h. 81 cm.
20. Charm gown. Coloured inks on a gown called *binjima*. Made by Malam Nuhu Mai Shaida. Zaria City, 1972. l. 105 cm.
21. Pottery ink-well. Kano, 1971. w. 13 cm.
22. Six balls of ink powder made of charcoal and soot. Kano, 1975. Average w. 4 cm.

18. Drawing for an embroidery design, by Alhaji Sanni of Kano.

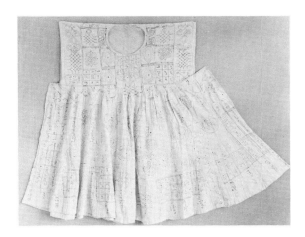

20. Charm gown.

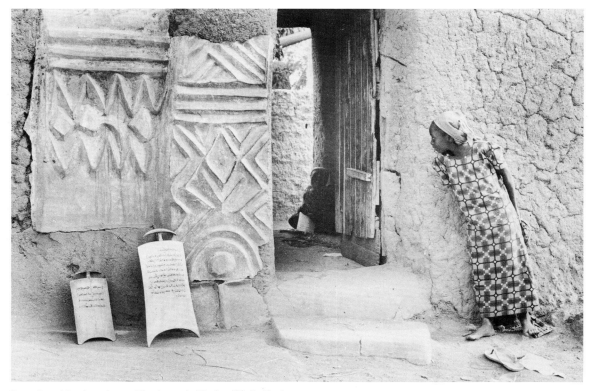

Quranic writing boards outside a house in Tudun Wada, Zaria.

Weaving

It is not known when cloth weaving began in West Africa, but looms may have been introduced there comparatively lately, with the type used today by the men, and often referred to as the Sudanese or band loom, arriving in Hausaland from the Near East, after a circuitous route via North Africa.

Since the aspect of Islamic culture that has been most readily taken up in West Africa is that of clothing, and since the large, loose gowns and trousers that have been adopted by the Hausa require a considerable amount of material, the extensive cultivation of cotton for weaving, even if the plant itself were indigenous, would have been greatly stimulated by outside Islamic influence, particularly from the fifteenth century onwards.

Hausa weavers use two types of loom. The women, who prepare and spin the raw cotton, work with a simple vertical structure and produce cloths that are about half a metre wide and two metres long. These are often made in pairs, one for use as a wrapper, and one to go over the head.

The men's loom is the horizontal, two-heddled, Sudanese type already mentioned. It is used to produce a long, narrow strip or band of cloth with, in most cases, a width of from two to eight centimetres. Sometimes the men weave out of doors, using a tree or a suspended mat for shade; otherwise the loom is set up inside a room in the family compound. The long warp threads are then stretched out through the open doorway and their ends are held down, as usual, on a potsherd or a stone. The craftsman usually works sitting low down, and as the work progresses he draws the warp threads towards him and winds the finished cloth onto a wooden rod that is positioned below his knees. Strip cloth of the kind made on the Sudanese loom is cut and sewn edge to edge to make women's wrappers and men's gowns, trousers and turbans. In the past, such cloth has also been used as a form of currency in West Africa.

The most common of the cloths made by the men are a plain white variety and a speckled one made by weaving together indigo and white, or light blue, threads. There are also several common striped varieties, each made up of two or more colours. Each particular design has its own name. One of the striped cloths, at present no longer made in Hausaland, consists of a mixture of biscuit-coloured wild silk and white cotton.

The traditional cloths made by the women are rather less strict in their designs and colour-combinations than those of the men. Most of them are striped, but some have decorative additions in the

form of inlaid patterns. These patterns are mostly small, linear, and in a colour contrasting with that of the cloth. One narrow type of white cloth, now obsolescent, used for supporting a woman's baby on her back, incorporates simple shapes representing Quranic writing boards and birds.

By the nineteenth century, Hausa production of woven cloth was considerable, and Barth wrote that very large quantities were being sent from Kano to other parts of West Africa, and across the Sahara to North Africa. With the coming of factory-made cloths, the number of traditional weavers has greatly diminished. Few of the men's handwoven cloths now produced are worn in the Hausa urban centres, and the chief remaining customers are some of the rural Hausa, the pastoral Fulani, and the Tuareg.

23. Roll of strip cloth in indigo and light blue, woven by a man, and called *sak'i*. Katsina, 1975. w. 4 cm.

24. Roll of strip cloth in white cotton, woven by a man, and called *fari*. Katsina, 1975. w. 7 cm.

25. Roll of strip cloth, woven by a man, and called *barage*. Katsina, 1975. w. 4 cm.

26. Man's loom used by Malam Tanko of Dalili village, south of Kano, 1975.

27. Trouser-string, woven by a man. Zaria City, 1974. w. 1 cm.

28. Short strip of cloth, woven by a man, and called *sak'i*. Zaria City, 1972. w. 10 cm.

29. Short strip of cloth dyed blue, and called *shu'di*. Zaria City, 1972. w. 8 cm.

30. Short strip of white cloth woven by a man. Zaria City, 1972. w. 7 cm.

31. Short strip of cloth woven by a man, and called *gwanda*. Zaria City, 1972. w. 7 cm.

32. Short strip of cloth woven by a man, and called *gwanda*. Zaria City, 1972. w. 7½ cm.

33. Short strip of cloth woven by a man, and called *kudi*, or *barage*. Zaria City, 1972. w. 5½ cm.

34. Short strip of Hausa cloth called *mudukare*, made mostly for the pastoral Fulani. Zaria City, 1972. w. 8 cm.

35. Length of white cloth made of strips, woven by men. Kano, 1975. l. 305 cm.

36. Length of indigo and light blue cloth, woven by men, and called *sak'i*. Kano, 1975. l. 158 cm.

37. Length of cloth called *kudi*. Kano, 1975. l. 173 cm.

38. Three lengths of cloth woven by men, and called *gwanda*. Kano, 1975. l. 152 cm.

39. Two cloths woven by women, and called *bunu*. Kano, 1975. l. 187 cm.

40. Length of cloth woven by women, and called *mudukare*. Zaria City, 1971. l. 155 cm.

41. Length of white cloth woven by women, with simple inlaid decoration including bird shapes. Kano, 1975. l. 160 cm.

42. Spindle of loosely hand-spun cotton. Zaria City, 1970. l. 24 cm.

43. White blanket of cloth woven by men, with decoration in black. Kano, 1975. l. 252 cm.

44. White blanket of cloth woven by men, with decoration in black. Kano, 1975. l. 256 cm.

45. Cloth, for tying a baby to a woman's back for carrying. Decoration in red and black. Funtua, 1975. l. 188 cm.

46. Seven spindles with whorls of painted pottery. Katsina and Cheranchi, 1975. l. 27 cm.

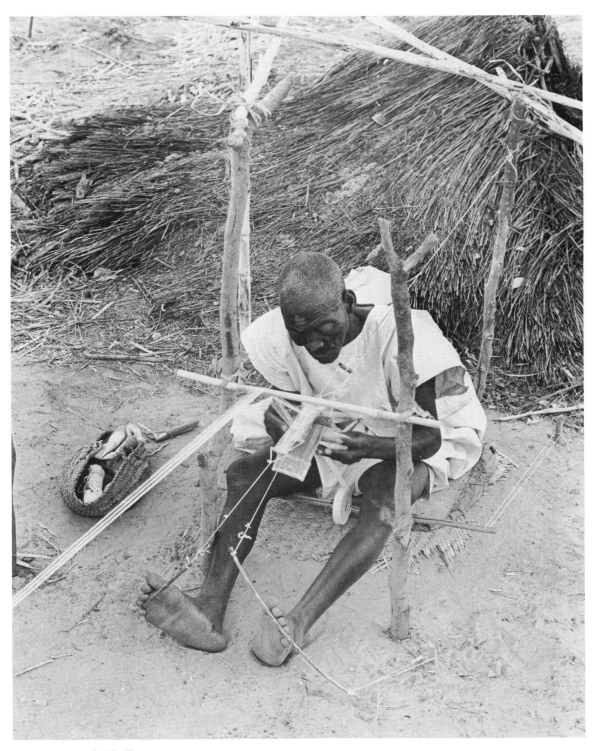

26. Man's loom. Dalili village.

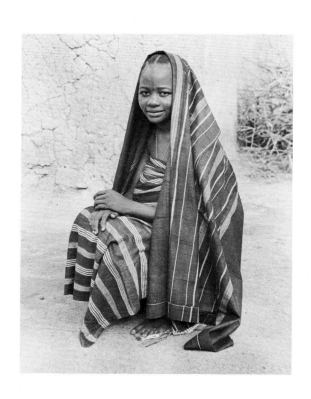

Woman of Zaria City wearing two cloths woven in Kano.

Spindle of cotton spun by a woman near Kura village, south of Kano.

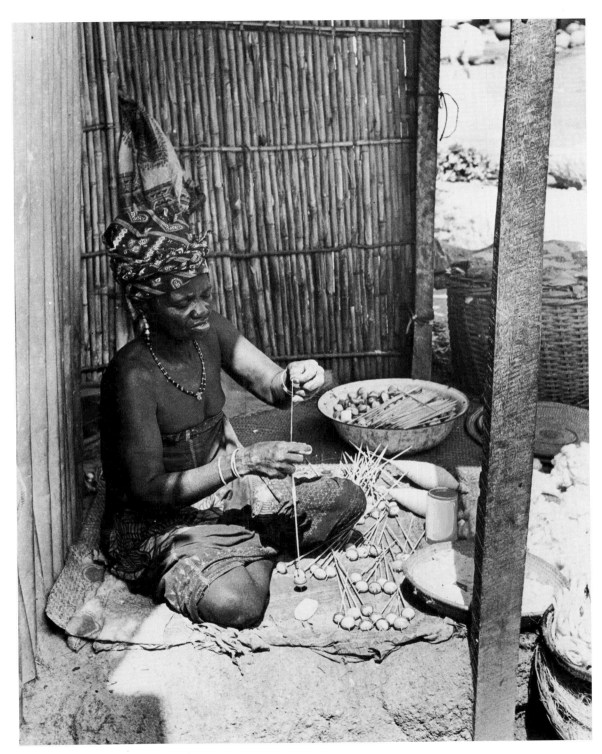

Woman spinning cotton in Kano Market.

Indigo Dyeing

The Hausa were once renowned in West Africa for the quality of their indigo-dyed cloth, and considering the competition from factory-made material, a surprising amount is still produced, though it is now nearly all made in the larger towns. Almost all the many dye pits in rural areas have been abandoned.

Though indigo plants are grown locally, the dyeing process seems to have been imported from the Orient via North Africa. Among the Hausa, it is the men who are the dyers, in contrast, for example, to the Yoruba, whose cloths are dyed in large pots by the women. The Hausa use circular, cement-lined pits, sited in clusters on sloping ground to avoid water-logged conditions during the rainy season, and each dyer has a group of pits for his own use. Hausa dye pits are several metres deep, and the traditional cement with which they are sealed is made by burning a heap of pear-shaped bricks containing sediment from the dye pits themselves. This cement is known as *katsi*, and in the past it was also commonly employed in protecting mud roofs and exterior walls against the rain.

The composition of the indigo-dye solution varies somewhat from one locality to another, but the ingredients are basically the same: wood ash, *katsi*, and partly-fermented indigo, which today is often supplemented with imported dye-powder. In preparing the dye solution, water is poured into the dye pit first and then the other materials are added. The mixture is allowed to mature over a period of about six days, and is stirred up several times with a long pole. At the end of the maturing period, the dyer will say that it is ready: '*Allah ya hura mashi rai*' (God has breathed life into it), and the dyeing can then proceed.

The depth of colour in a cloth depends partly on the number of times it is dipped in the dye solution. It may be increased by a beating process that is used in the manufacture of the very dark, shiny turban cloths that are sold to the Tuareg and worn also by some of the older Hausa men. Damp, already-dyed cloth is laid over a log of wood and sprinkled with powdered indigo, while at the same time it is pounded with heavy wooden mallets. Suet is also added, to bind the pigment together, though the indigo powder never becomes really fixed, and part of the attractiveness of indigo-dyed cloths among the people who use them is clearly that the dye does come off, and tints not only the skin, but also any light-coloured clothes that are being worn at the same time.

A small range of tie-and-dye patterns are produced by Hausa dyers, and a few also by means of the 'resist' method, in which paste

and metal stencils are used. However, the Hausa terms for these designs indicate that they have come from Southern Nigeria and even East Africa, and the techniques can be of no great antiquity in Hausaland, even though some of the dyers say that they have been in use there for a long time.

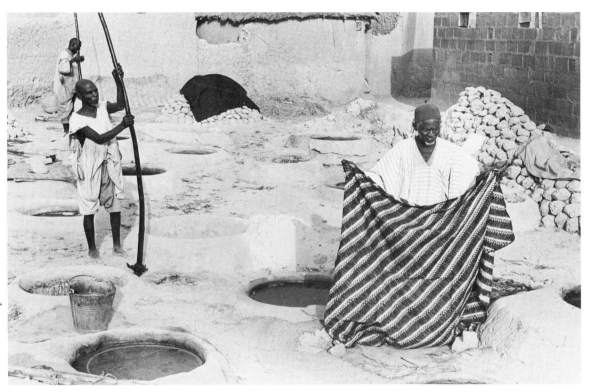

54. The dyer Alhaji Salihu Marini at one of the groups of dye pits in Zaria City.

47. Man's gown dyed with indigo, in the two-toned, now obsolescent, effect known as 'crow'. Zaria City, 1975. l. 131 cm.

48. Man's gown dyed with indigo. Kano, 1975.

49. Turban cloth heavily dyed with indigo and beaten glossy. Zaria City, 1975. w. 38 cm.

50. Cloth with hand-sewn, indigo tie-and-dye design by Alhaji Salihu Marini, the pattern called *mai k'ok'o* (small calabash). Zaria City, 1975. l. 179 cm.

51. Cloth with hand-sewn, indigo tie-and-dye design by Alhaji Salihu Marini, the pattern called *adiren 'da* (old *adire*). Zaria City, 1975. l. 175 cm.

52. Cloth with hand-sewn, indigo tie-and-dye design by Alhaji Salihu Marini, the pattern called *mai gidan waya* (post office). Zaria City, 1975. l. 182 cm.

53. Cloth with hand-sewn, indigo tie-and-dye design by Alhaji Salihu Marini, the pattern called *mai zube* (linear tribal marks). Zaria City, 1975. l. 175 cm.

54. Cloth with hand-sewn, indigo tie-and-dye design by Alhaji Salihu Marini, the pattern called *lalaftu* (running stitch). Zaria City, 1975. l. 180 cm.

55. Cloth dyed with indigo, the white design having been first painted on to the cloth with cassava paste, using a metal stencil that was made by a Hausa smith but owned by a Yoruba woman. The pattern is called *mai adaka* (metal box), presumably because the designs on the local versions of these are also painted with the aid of stencils. Zaria City, 1975. l. 181 cm.

56. Short strip of hand-woven cloth, heavily dyed with indigo and called *bak'i* (black). Zaria City, 1972. w. 7 cm.

57. Cloth dyed with indigo, with tie-and-dye pattern called *rimin Kampala* (Kampala design). Kano, 1975. l. 77 cm.

58. Cloth dyed in indigo, and decorated with the tie-and-dye pattern called *rimin Kampala*. Kano, 1975. l. 163 cm.

59. Faded man's gown with machine-embroidered decoration, having some time previously been dyed in Sokoto. Zaria City, 1974. l. 133 cm.

60. Stencil with palm-tree design, used for producing cassava paste resist patterns. Made by a Hausa smith and owned by a Yoruba woman. Zaria City, 1975. h. 46½ cm.

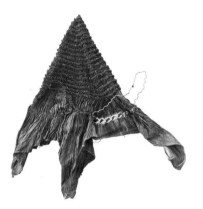

57. A tie-and-dye cloth from Kano, indigo dyed, and still tied up except for one small portion.

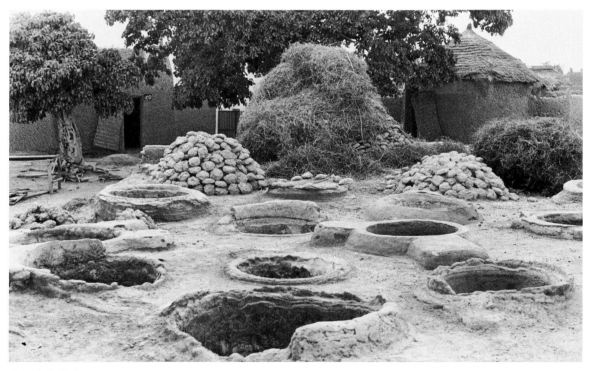

Dye pits in Zaria City and piles of *katsi*. Some of the pits shown are disused.

Embroidery

The earliest embroidery in Hausaland must have been imported, but by the fifteenth century there were probably a few local craftsmen making embroidered clothes in the larger Hausa settlements such as Kano. The Fulani *jihad* (holy war) at the beginning of the nineteenth century discouraged ostentatious living, and this would have affected not only music and dancing but also clothing, so that the more elaborate forms of embroidery used for Hausa dress today can be considered a comparatively recent development.

An important contribution to the evolution of a truly Hausa type of embroidery was made when two distinct types of pattern were brought together. One of these consists principally of interlacing forms, and is essentially Oriental in character. The other is of angular and spiral shapes and is a more indigenous type of decoration commonly applied to a great deal of African ware such as pots, wooden food bowls and baskets. It is very likely that these two types of ornament were put together by Quranic scholars, some of whom draw out embroidery designs preparatory to their being sewn.

Most Hausa embroidery is made for men's clothes. It is also the men who do most of the sewing. The embroidery on women's clothes has been derived almost exclusively from decoration evolved for men's garments. In the past, some of the women living in the emirs' courts occasionally wore men's clothes draped over them, and embroidered men's gowns traded to Ghana were also, in some cases, put to use by women there, who cut them so that they could be worn as wrappers.

In recent years, Hausa women have begun to produce a range of rather colourful embroidered decoration on bed covers and pillowcases. This kind of work has been influenced by Sudanese and Near Eastern models and constitutes a new field of artistic work in Hausaland.

Papers in which I have discussed various aspects of Hausa embroidery are included in the bibliography at the end of this catalogue.

61. Man's trousers of hand-woven strip cloth, with embroidery by Malam Tanko Liman. Zaria City, 1971. w. 168 cm.

62. Woman's wrapper of hand-woven strip cloth, with preliminary drawing for the embroidery pattern called *'dan Katsina* (son of Katsina). Drawing by Malam Bashari Mai Gini, using a mixture of red potash and porridge. Zaria City, 1972. l. 169 cm.

63. Man's short gown, called *gambari*, or *'yar ciki*, made for the pastoral Fulani, and worn also by some Hausas. Kano, 1974. l. 86 cm.

64. Man's gown of light blue cloth, with machine-embroidered pattern called *'yar Dakar* (daughter of Dakar) or *'yar Kumasi* (daughter of Kumasi). Zaria City, 1969. l. 122 cm.

65. Man's trousers, called *wando mai surfani*, of white cloth, with hand-embroidered pattern. Kano, 1964. w. 156 cm.

66. Woman's blouse, called *riga mai aikin zina* (blouse with *zina* embroidery), now obsolete. Made and embroidered by Malam Tanko Liman. Zaria City, 1973. l. 49 cm.

67. Man's gown, of the type known as *tokare*, hand-embroidered by Ibrahim Nagogo in wild silk that was collected north of Bauchi and prepared in Zaria City. The pattern is called *balluha* or *aska biyu* (two knives), and the cloth *mai suga* (sugar-lump pattern). Zaria City, 1973–4. l. 146 cm.

68. Woman's wrapper, of narrow strip cloth, embroidered by Malam Tanko Liman with a *zina* embroidery pattern, now obsolete, and called *'dan dunfama* (son of a tireless worker). Zaria City, 1973. l. 170 cm.

69. Woman's wrapper of narrow strip cloth, embroidered by Malam Tanko Liman with a *zina* embroidery pattern, now obsolete, and called *'dan Katsina* (son of Katsina). Zaria City, 1973. l. 149 cm.

70. Man's black burnous, with Mecca-style metallic decoration. Katsina, prior to 1971. l. 169 cm.

71. Man's gown, embroidered by Hassan 'Danmagama in several shades of green with a pattern that combines elements of the *malum-malum* and *'yar Bornu* (daughter of Borno) designs. Katsina, 1970. l. 135 cm.

72. Man's short gown, called *gambari* or *'yar ciki*, made for the pastoral Fulani, and worn also by some Hausas. Kano, 1974. l. 96 cm.

73. Man's gown, with machine-embroidered pattern called *Allah bar Sarki* (Long live the King!). Zaria City, 1974. l. 137 cm.

74. Man's gown, embroidered by Alhaji Sanni with a pattern called *'yayin Sharif mai wata* (the Sharif design, with a moon). Kano, 1974. l. 137 cm.

75. Man's gown of narrow strip cloth, embroidered with a simple version of the pattern called 'two knives'. Bungudu, 1971. l. 131 cm.

76. Man's gown, embroidered with imported, silky thread by Malam Lawal of Anguwar Lalle. The pattern, now obsolescent, is called *gurasa*. Zaria City, 1973. l. 148 cm.

77. Man's gown, decorated with an old version of the pattern called 'two knives'. Zaria or Kano, before 1970. l. 124 cm.

78. Woman's wrapper of narrow strip cloth, with machine embroidery. Sokoto, 1970. l. 126 cm.

79. Man's gown. A modern, machine-embroidered version of the older *binjima*, which had a flared skirt. This type of garment is commonly worn by the pastoral Fulani, and recently also by young Hausa men. Zaria City, 1970. l. 96 cm.

80. Man's gown, machine embroidered with the pattern called *'yar Kumasi* (daughter of Kumasi). Zaria City, 1975. l. 140 cm.

81. Man's gown, embroidered with a 'two knives' pattern also called *allura biyu* (two needles) which is an oblique reference to the bright colours used. Kano, 1975. l. 143 cm.

82. Man's gown, embroidered in wild silk with a pattern called *shabka mai yanka* (*shabka* with gaps). Zaria City, 1975. l. 140 cm.

83. Man's gown, embroidered in wild silk with a pattern called *shabka mai yanka* (*shabka* with gaps), the preliminary drawing done by Malam Nuhu of K'ofar Kuyambana. Zaria City, 1971. l. 141 cm.

84. Man's gown, embroidered with a 'two knives' pattern also called *allura biyu* (two needles). Kano, before 1975. l. 124 cm.

85. Woman's blouse, embroidered by Alhaji Sanni with a design of the kind worn in Kano in the 1950s and now obsolete. Kano, 1973. l. 70 cm.

86. Woman's wrapper, decorated by Alhaji Sanni and influenced by women's embroidered cloths brought to Hausaland from Mecca by returning pilgrims. Kano, 1975. l. 174 cm.

87. Woman's wrapper, with embroidered panel. Sokoto, 1971. l. 190 cm.

88. Man's gown made of strip cloth from western Nigeria, and embroidered by Malam Sulaiman of Anguwar Limanci with wild silk prepared in Zaria. The pattern is called *'yar Ilori* (daughter of Ilorin). This is a variation of a design used by Hausa, Nupe and Yoruba embroiderers. Zaria City, 1971–3. l. 154 cm.

89. Man's gown, with machine and hand embroidery. The pattern is called *shabka*. Zaria City, 1970. l. 131 cm.

90. Man's gown, embroidered with a pattern called *aska takwas, allura biyu* (eight knives, two needles). Kano, before 1971. l. 136 cm.

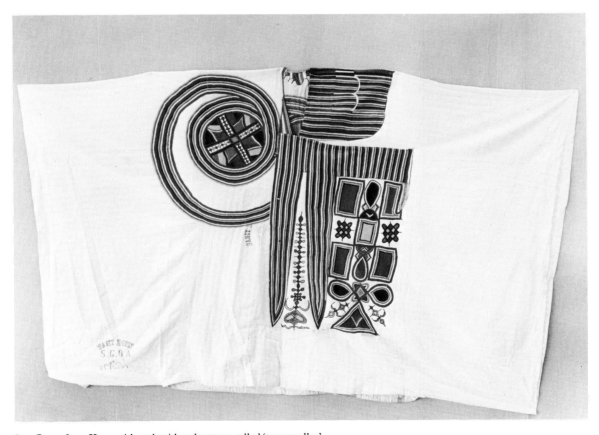

81. Gown from Kano with embroidered pattern called 'two needles'.

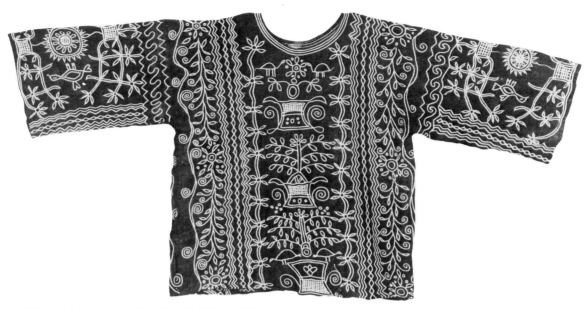

85. Woman's blouse embroidered by Alhaji Sanni of Kano.

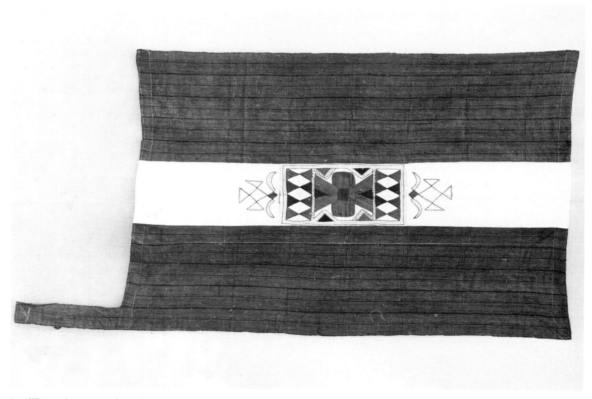

87. Woman's wrapper from Sokoto.

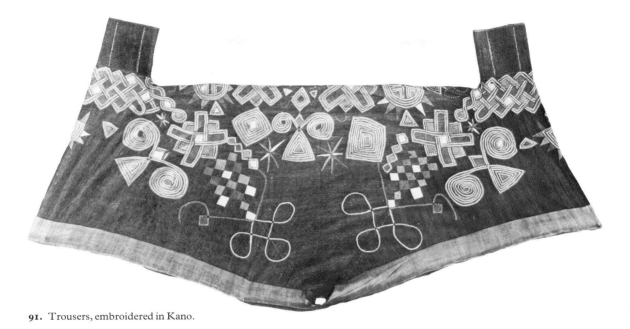

91. Trousers, embroidered in Kano.

91. Man's trousers made of strip cloth, and called, on account of the embroidery, *mai surfani* (with chain stitch). Kano, before 1974. w. 230 cm.

92. Man's gown, embroidered in wild silk with a pattern called *shabka mai huje-huje* (*shabka* with holes). Kano, the cloth said to date from about 1950. l. 147 cm.

93. Man's gown, with half-completed embroidery in Anchor thread on Kaduna cloth by Malam Gambo, the pattern called *malum-malum*. Zaria City, 1971. l. 148 cm.

94. Man's gown, embroidered in green thread with a pattern called *'yar Madaka* (daughter of Madaka). Zaria City, 1971. l. 139 cm.

95. Man's gown, embroidered in various shades of wild silk thread with a pattern called *'yar Madaka* (daughter of Madaka). Nine people worked on this gown, including the tailor, the embroidery draughtsman and the man who finally beat the gown, in lieu of ironing. Zaria City, 1971. l. 144 cm.

96. Man's gown, called *barage* on account of the cloth, with a green-embroidered pattern called 'two knives'. Kano, before 1969. l. 145 cm.

97. Man's sleeveless gown of red and white cloth, as worn by some of the attendants of the Emir of Katsina. Made by Malam Zagi. Katsina, 1971. l. 98 cm.

98. Man's gown, embroidered with a pattern called *malum-malum*. Zaria City, before 1974. l. 135 cm.

99. Man's gown, decorated by three embroiderers with a pattern called *'yar Dikwa* (daughter of Dikwa). Sokoto, 1970. l. 124 cm.

100. Man's gown, with a machine-embroidered pattern called *'yar Kumasi* (daughter of Kumasi), made by Malam Mansir. Zaria City, before 1973. l. 120 cm.

101. Man's gown of red-striped cloth, with machine-embroidered imitation of the hand-embroidery design called 'two knives'. Kano, before 1969. l. 139 cm.

102. Man's gown of hand-woven white cloth, with machine-embroidered pattern made in the workshop of Alhaji Mahadi, and called *'yar Tambutu* (daughter of Timbuktu) or *mai gidan dara*. Kano, before 1970. l. 129 cm.

103. Man's gown, with machine-embroidered pattern called *'yar Dakar* (daughter of Dakar). The appearance of the embroidery is distinctly exotic. Zaria City, before 1970. l. 110 cm.

104. Man's gown, waistcoat and trousers, the garments and the embroidery being of an exotic, 'Mecca' type, made by Alhaji Ahmadu near the City market. Kano, 1971.

105. *Marafiya*-type green cap, embroidered in red, with a design called 'groundnuts', by Malam Shehu Bajimi of Bajimi village near Zaria, 1973. h. 20 cm.

106. *Marafiya*-type green cap, embroidered in red, with a design called 'cock's eye', by Shehu Bajimi of Bajimi village, near Zaria, 1973. h. 19½ cm.

107. Yellow cap, embroidered in green and orange with a design called 'Let's meet at the bank'. Zaria City, 1971. h. 19½ cm.

108. Blue cap, embroidered in red, yellow and white by Ibrahim Magaji. Zaria City, 1971. h. 15½ cm.

109. *Marafiya*-type cap, embroidered with white cotton by Malam Shehu Bajimi of Bajimi village, near Zaria, 1973. h. 19 cm.

110. White cap, of the *bakwala* variety, made for the pastoral Fulani, and worn also by some Hausas. Embroidered in several colours, among the motifs of which are two schematic lizards. Kano, 1971. h. 22 cm.

111. Cap, with a pattern called 'L', or 'with axes', embroidered by Mohammedu Salihu. Zaria City, 1970. h. 19½ cm.

112. Cap, embroidered with nine colours and called *k'ube*, which is a general name for a cap with multicoloured embroidery. Zaria City, 1973. h. 16 cm.

113. Dark blue cap, with white and light blue embroidery; the pattern is called 'cloves'. By Malam Salihu Jega. Zaria City, 1973. h. 17 cm.

114. Lilac-coloured cap, with cream, ochre, and brown-coloured embroidery by Malam Salihu Jega. Zaria City, 1973. h. 19 cm.

115. White cap, called *marafiya mai 'duri*, with embroidery in white, by Malam Shehu Bajimi. Some parts of the design are emphasized by inserting cotton thread between the two layers of cloth, after which the embroiderer clenches his teeth on them to make them more prominent. Bajimi village, near Zaria, 1973. h. 18 cm.

116. Cream-coloured cap with beige embroidery, one of the names for this kind of pattern being 'a thousand ant holes'. Zaria City, 1973. h. 17 cm.

117. White cap, with embroidery in several colours; the pattern is called *Mambila* (the name of a range of mountains). The embroiderer of this unique design was a Quranic scholar. Zaria City, 1973. h. 14½ cm.

118. White cap, with green-embroidered pattern made without any preliminary drawing by Malam Salihu Jega. Zaria City, 1973. h. 16 cm.

119. White cap of the *marafiya*-type, embroidered in white. Giwa, 1973. h. 15 cm.

120. Cap of the type called *ha'bar kada*, with an embroidery design representing a mosque. Dambatta, before 1975. h. 35 cm.

120a. Preliminary drawing on cloth for hand-embroidered cap decoration called 'Mambila mountains'. Zaria City, 1974.

120b. Pillowcase, with decoration including footballers, embroidered by a woman, Ladidi Usman. Katsina, 1975. l. 73 cm.

120c. Pillowcase, with decoration featuring a crocodile, embroidered by a woman. Argungu, 1974. l. 84 cm.

120d. Bedcover, embroidered with animal and plant forms by a woman. Jibiya, 1975. l. 181 cm.

120e. Bedcover, with a design that includes three scorpions, embroidered by a woman, Ladidi Usman. Katsina, 1975. l. 178 cm.

120f. Bedcover, with machine-embroidered design that includes three scorpions, by a woman, Ladidi Usman. Katsina, 1975. l. 175 cm.

120g. Man's short, embroidered gown, called *gambari*, a type worn by the pastoral Fulani and some Hausas. Garko village, near Kano, 1973. h. 83 cm.

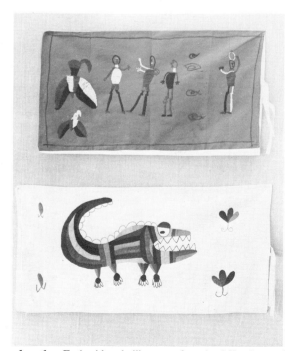

120b and c. Embroidered pillowcases from (top) Katsina, and (bottom) Argungu.

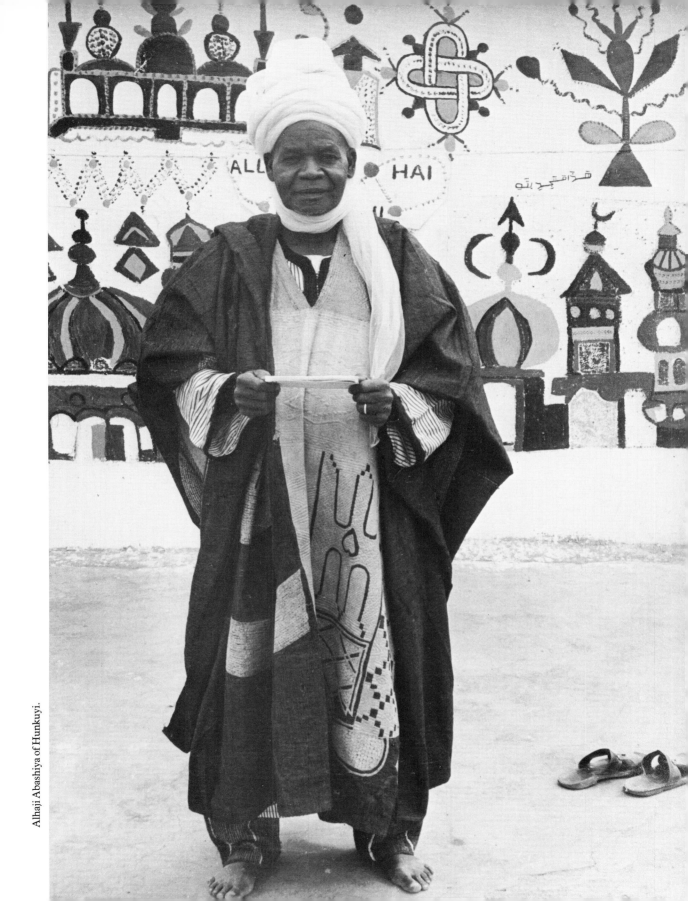

Alhaji Abashiya of Hunkuyi.

Man in Jema'a village with a hand-embroidered gown
from Kano.

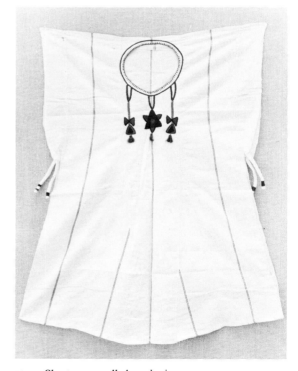

120g. Short gown, called *gambari*.

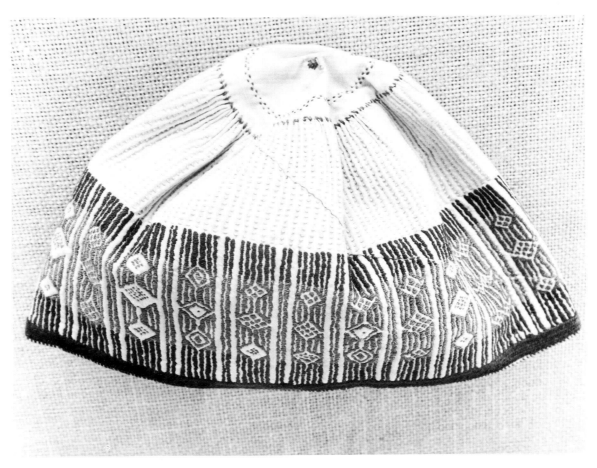

114. Hand-embroidered cap from Zaria City.

Basketry

Hausa basketry is essentially utilitarian, and the more elaborately decorated Hausa products are inspired by Fulani work, which is generally finer in texture and more subtle in its ornamentation.

The Hausa use the coiled-basketry method for making containers and circular covers for food bowls, and a weaving technique for small kitchen fans and circular trays.

The materials, which are mostly collected during the rainy season and used throughout the year, are worked in a damp state so that they remain supple. The inner structure of the coils, in the case of the coiled basketry, is made of elephant grass, and dum-palm fronds are sewn on to this to create the outer layer. Dum-palm fronds are also used for woven basketry, and root fibres of the same plant are made into basketware caps that are a copy of a type often brought back to Hausaland from Mecca by returning pilgrims.

Only a small range of colours is used for traditional Hausa basketry, the palm fronds being first boiled in water containing the dye-stuffs and then laid out on mats to dry. The most common colours are black and red. The black is usually made with an imported dye powder; the red is obtained either with red potash or from the leaf sheaths of a type of sorghum grown specially for the purpose and known as *karan dafi*. *Karan dafi* dye is also one of the materials used for some of the preliminary drawings done on cloth for embroidery, and in certain calabash decoration and leatherwork.

There is a current tendency in some areas for Hausa basketry decoration to become less conventional and more colourful; but the older, more vigorous type of work is still being made.

121. Seven containers, made of coiled basketry. Kano, 1975. Average w. 61 cm.

122. Basket. Kano, 1975, w. 32 cm.

123. Baskets. Kano, 1975. w. 30 cm.

124. Basketwork cap, made by a young boy. It is an imitation of a similar type often brought back from Mecca by returning pilgrims. Zaria City, 1973. h. 17 cm.

125. Three stands for pots. Jibiya, 1975. w. 11½ cm.

126. Fan, for fanning a fire, made of woven dum-palm fronds. Katsina, 1975. l. 36 cm.

127. Fan, for fanning a fire, made of woven dum-palm fronds. Katsina, 1975. l. 36 cm.

128. Fan, for fanning a fire, made of woven dum-palm fronds. Zaria City, 1975. l. 38 cm.

129. Two stands for pots, made of guinea-corn leaves. Zaria City, 1975. w. 10½ cm.

130. Circular mat of coiled basketry. Zaria, 1975. w. 34 cm.

131. Circular mat of coiled basketry. Zaria, 1975. w. 39½ cm.

132. Tray of woven basketry, such as is used by market traders selling spices, antimony, etc. Zaria City, 1975. w. 46 cm.

133. Tray of woven basketry. Zaria City, 1975. w. 41 cm.

134. Circular mat of coiled basketry. Kano, 1967. w. 36 cm.

135. Circular mat of coiled basketry. Kano, 1975. w. 28½ cm.

136. Circular mat of coiled basketry. Kano, 1975. w. 33 cm.

137. Circular mat of coiled basketry. Kano, 1975. w. 38 cm.

138. Circular mat of coiled basketry. Kano, 1975. w. 35½ cm.

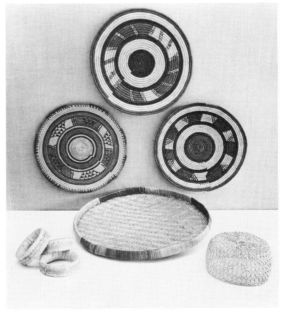

122, 123, 132, 125, 124.
Three coiled baskets, three pot or calabash stands, a woven tray, and a basketry cap.
From the area of Kano and Zaria.

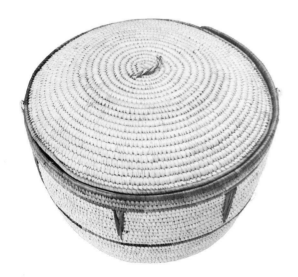

121. Container and lid of coiled basketry.

Calabash Decoration

Calabashes, or gourds, are the fruits of several varieties of creeper, some of which are grown along with farm crops, while others are encouraged to trail over fences and thatched roofs. There are many sizes and several distinct shapes of calabash, and each is put to special uses. The smaller ones are made into water or ink containers, or they are split and become dishes or ladles. Large, spherical calabashes are fitted with handles and are used as primitive rafts by fishermen. More commonly, the larger calabashes are cut in halves for holding grain or other dry material, or they are sold to the pastoral Fulani as milk containers, in which case they are invariably first finished with white clay, which is rubbed over the already carved and dampened surface of the calabash. The Fulani also decorate calabashes themselves, but their work is far less abstract than that of the Hausa. Hausa women immerse their hands in tube-shaped calabashes when they dye the palms of their hands in henna. A long narrow type is cut open at both ends and used by them as a musical instrument, known as *shantu*. This is one of the many connections between calabashes and Hausa music.

When a large calabash is to be decorated, the ripe fruit, which may have been stored for some months after harvesting, is either sawn in half and cleaned out with a curved knife or opened at one end and soaked in water.

Where a calabash has been immersed in water, the inner tissue and the outer skin disintegrate and can be easily removed. If it has not been soaked, the outer skin is sometimes scraped with a short metal tool to produce delicate linear decoration which shows up as a slight tonal contrast.

Several other methods are common: carving and sawing, burning (pyro-engraving) and scorching with heated metal tools, colouring with *karan dafi* dye, and whitening with clay.

Though decorated calabashes are used mainly for practical purposes, some were formerly collected by Hausa women for decorating their rooms. The use of calabashes in this way has now been almost completely superseded by displays of brightly-coloured enamelware, which some women collect in astonishing quantities.

Most calabash decoration among the Hausa is the work of the men.

139. Calabash, with scraped decoration made with a metal tool. Jibiya, 1975. w. 139 cm.
140. Calabash, with carved decoration. Jibiya, 1975. w. 33 cm.
141. Calabash ladle, with pyro-engraved decoration. Cheranchi, 1975. l. 22 cm.
142. Calabash ladle, with pyro-engraved decoration. Cheranchi, 1975. l. 23 cm.
143. Calabash ladle, with pyro-engraved decoration. Cheranchi, 1975. l. 24 cm.
144. Calabash, with carved and pyro-engraved decoration. Jibiya, 1975. w. 23½ cm.
145. Calabash with carved decoration. It was originally used as a container, then turned upside down to become a stool.
146. Calabash, with carved decoration. Used by a market trader as a container for salt. Sokoto, 1971. w. 56 cm.
147. Calabash, with decoration made by carving, dyeing and scraping; several parts also whitened with clay. This type was formerly used by women purely for ornamental purposes. Jibiya, 1971. w. 40 cm.
148. Calabash, with carved decoration. Zaria City, 1975. w. 22 cm.
149. Calabash, with carved decoration. Zaria City, 1975. w. 43 cm.
150. Calabash, of the type used by women and girls in dyeing their hands with henna. Pyro-engraved decoration with additional work in leather, including a loop for hanging up the calabash when not in use. Sokoto, the leather decoration done by Alhaji Balarabe in Zaria City, 1973. l. 31 cm.
151. Calabash, with pyro-engraved decoration. Katsina, 1975. w. 32 cm.
152. Calabash, with carved decoration. The cracked, outer skin of the calabash is still in position. Jibiya, 1975. w. 45 cm.
153. Calabash, with carved decoration. Kaduna, before 1973. w. 24½ cm.
154. Calabash, with carved decoration. Zaria City, 1975. w. 50 cm.
155. Calabash, with carved decoration, a large part of which represents cowrie shells. Zaria City, 1975. w. 43 cm.
156. Calabash, with pyro-engraved decoration made by a Hausa woman. Kafanchan, 1975. w. 12 cm.
157. Calabash, with pyro-engraved decoration made by a Hausa woman. Kafanchan, 1975. w. 13 cm.
158. Calabash, with pyro-engraved decoration made by a Hausa woman. Kafanchan, 1975. w. 22½ cm.
159. Calabash, with carved decoration probably representing cowrie shells. Zaria City, 1975. w. 29 cm.
160. Calabash, with pyro-engraved decoration and a wooden stopper. Used as a container for sour milk. Kano, 1975. h. 29 cm.
161. Calabash, with carved and stained decoration. Kano area, 1974. w. 36 cm.

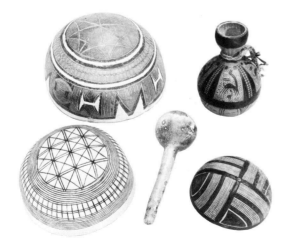

147, 160, 150, 158.
Calabashes from (top left) Jibiya, (top right) Kano, (bottom left) Katsina, and (bottom right) Kafanchan.

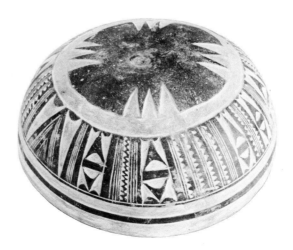

148. Small carved calabash.

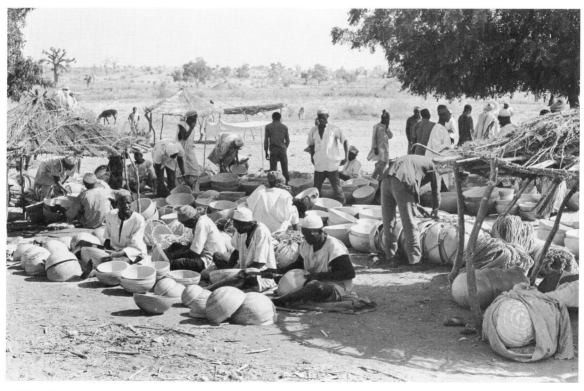

Calabash decorators in a market near Katsina.

Leatherwork

Hausa leatherwork still flourishes, even though articles such as leather sandals must now compete with rubber and plastic types, while a few others, such as embroidered leather boots, are virtually obsolete.

The range of traditional Hausa leatherwork is large, and includes bags, wallets, boxes, satchels for carrying the Qur'ān, sheaths, scabbards, cushions, headpads, calabash stands, and several kinds of footwear. Leather handles and decoration are frequently added to articles such as domestic sieves, straw hats, musical instruments, ink pots, and Quranic writing boards. A great variety of horse trappings is also produced by the Hausa leatherworkers. Apart from the pommel cover (no. 173), all the examples listed in this catalogue are in a separate section.

The kind of leather that is most used, especially for decorative work, is goatskin. It is frequently dyed to a bright red colour, and it is easy to work. When it needs to be stiffened, this is done with cardboard, to which the leather can be effectively fixed, using porridge as a glue. Traditional leatherworkers also make use of cattle hides, and sheep, lizard, snake, and occasionally even fish skin.

Modern tanning processes have now been established in several Hausa centres, but traditional techniques show no sign of disappearing. With the older methods, the skins are soaked for several days in water to which ash and the seed-pods of Egyptian mimosa have been added. They are then placed over old wooden mortars and the outer, hairy layer is removed with a two-handled metal scraper. After further steepings in the tanning solution and clear water, the skins can be whitened with milk or coloured with local vegetable, or imported, dyes, the traditional colours being red, black, yellow and a bright green.

The ornamentation of the leatherwork is done in various ways: by applying a stain consisting of water and dye powder (or, in the case of black, iron oxide), by embroidering with thin strips of coloured leather, by incising and punching patterns with metal tools, by knotting, plaiting and weaving, by an appliqué technique that combines gluing and stitching, and by a stripping method in which areas of the top surface are removed to create contrasts of dyed and undyed leather.

A sizeable industry has grown up in the last fifty years, producing semi-traditional material for sale to visitors in Nigeria: writing cases, mats, purses, and a variety of bags. A considerable amount of reptile skin is used for this, and in some urban areas whole families have become involved in the work.

162. Leather container for flint and steel (*gidan k'yastu*). Jibiya, 1975. l. 16½ cm.

163. Pair of riding boots, in yellow leather, with punched and embroidered decoration. Kano area, 1972. l. 51 cm.

164. Leather cushion, made by Alhaji Balarabe. Zaria City, 1973. w., including fringe, 54 cm.

165. Pair of sandals, Sokoto, 1971. l. 31 cm.

166. Cylindrical razor case of a type now mostly superseded by barber's wallets, though still occasionally made in Zaria City for the devotees of the *bori* cult who like to make razors available for the convenience of the spirits. Made by Alhaji Balarabe. Zaria City, 1972. l., when closed, 19½ cm.

167. Leather apron, made by Alhaji Balarabe for a devotee of the *bori* cult of spirit possession. Zaria City, 1973. w., without tie-pieces, 73 cm.

168. Box for loose papers, made by Alhaji Balarabe. Zaria City, 1972. w. 25 cm.

169. Pair of riding boots, made by Alhaji Balarabe. Zaria City, 1973. l. 41 cm.

170. Bag, favoured by the pastoral Fulani as a purse, and known as *jakan Filani*. Made by Alhaji Balarabe. Zaria City, 1972. l. 18½ cm.

171. Double purse, for suspension from the neck, and almost certainly derived from a more elaborate Tuareg type. Made by Alhaji Balarabe. Zaria City, 1972. l., including tassels, 25 cm.

172. Knife-handle decoration and knife sheath, with leather ring for slipping over the arm for carrying. Made by Alhaji Balarabe. Zaria City, 1973. l. 37 cm.

173. Pommel cover, made by Alhaji Balarabe. Zaria City, 1973. l., without tabs, 24 cm.

174. Body of a fan, which if completed would have had ostrich feathers attached. Made by Alhaji Balarabe. Zaria City, 1973. l. 38 cm.

175. Small box for holding loose papers. Made by Alhaji Balarabe. Zaria City, 1971. w. 17½ cm.

176. Sandals, known as *takalmin aure* (marriage sandals), of the type formerly included in Zaria City in a girl's dowry, but now largely replaced by rubber and plastic types. Made by Alhaji Balarabe. Zaria City, 1973. l. 28 cm.

177. Leather container for flint, steel, and tinder (*gidan k'yastu*), made by Alhaji Balarabe. Zaria City, 1972. l., with tassels, 29 cm.

178. Purse with draw-strings, made by Alhaji Balarabe. Zaria City, 1973. l. 20 cm.

179. Mirror case, made by Alhaji Balarabe for his wife. Zaria City, 1972. l. 20½ cm.

180. Leather decoration on a small container for tobacco or snuff, and called *battan taba*. Made by Alhaji Balarabe. Zaria City, 1972. l., including loop, 23½ cm.

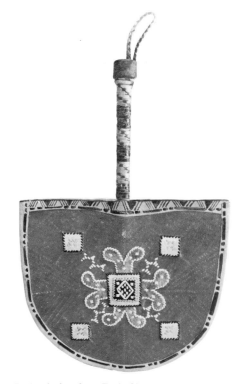

174. Body of a fan, from Zaria City.

181. Small purse for suspension from the neck, called *jakan wuya*. Made by Alhaji Balarabe. Zaria City, 1972. l. 12 cm.
182. Leather container for tinder, called *jakan alhawami*. Made by Alhaji Balarabe. Zaria City, 1972. l. 13 cm.
183. Purse for suspension from the shoulder, made by Alhaji Balarabe. Zaria City, 1972. l. 17 cm.
184. Belt of the type made specially for the Jaba people, who have no leatherworkers of their own. Called *gurun Jaba* and made by Alhaji Balarabe. Zaria City, 1972. l., excluding the loose ends, 80½ cm.
185. Money-belt, called *gurun ku'di*, made by Alhaji Balarabe. Zaria City, 1952. l. 42 cm.
186. Calabash stand of grass covered with leather, made by Alhaji Balarabe. Zaria City, 1973. w. 15½ cm.
187. Four leather charm cases for written charms, made by Alhaji Balarabe. Zaria City, 1972. Average l. 7½ cm.
188. Headpad, used by the pastoral Fulani for supporting a calabash, and known as *gammo*, made by Alhaji Balarabe. Zaria City, 1973. w. 11 cm.
189. Bangle charm, made by Alhaji Balarabe. Zaria City, 1972. w. 9 cm.
190. Three needle cases. The two more elaborate types are now obsolete. Made by Alhaji Balarabe. Zaria City, 1971. l. 27, 30½, 30½ cm.
191. Leather decoration on a container for holding antimony, called *tandu mai 'dunki* or *tandu mai baza*, made by Alhaji Balarabe. Zaria City, 1972. l., including fringe and loop, 28 cm.
192. Belt, of the kind worn under the clothing and containing written charms, made by Alhaji Balarabe. Zaria City, 1972. l., excluding the loose ends for tying, 77 cm.
193. Razor case used for a barber's razor or a folding knife. A barber would keep the razor of a special customer in a case such as this. Made by Alhaji Balarabe. Zaria City, 1972. l., with loop for suspension, 27½ cm.
194. Scissors case, made by Alhaji Balarabe. Zaria City, 1973. l. 29 cm.
195. Leather bag with a fringe, known as *jaka mai baza*. It consists of two flaps and is popular with Hausa women. Made by Alhaji Balarabe. Zaria City, 1971. l., including fringe, 36 cm.
196. Triangular-shaped amulet, which would normally contain a written charm, made by Alhaji Balarabe. Zaria City, 1973. l., including the loop, but excluding the cord, 8 cm.
197. Tweezers case for holding locally-made tweezers used for extracting splinters, etc., made by Alhaji Balarabe. Zaria City, 1972. l., including suspension loop, 27½ cm.
198. Sieve decorated with leather. This is a comparatively modern piece of kitchen equipment, as sieves were previously of basketwork. Made by Alhaji Balarabe. Zaria City, 1973. w. 21 cm.
199. Charm case of lizard skin, made by Alhaji Balarabe. Zaria City, 1972. l. 5 cm.
200. Leatherworker's thimble of monitor-lizard skin. Zaria City, 1973. w. 3 cm.
201. Leather shoes embroidered with coloured thread. Kano, 1974. l. 32 cm.
202. Leather shoes embroidered with coloured thread. Kano, 1975. l. 30½ cm.
203. Cutlass sheath and decorated cutlass handle, made by Alhaji Balarabe. Zaria City, 1973. l. 82½ cm.
204. Three leatherworker's awls with pyro-engraved handles. Jibiya, 1975. l. 16 cm.
205. Cover for the Qur'ān, called *tadarishi*. It folds around the loose sheets of the Qur'ān and both are then housed in a satchel. Made by Alhaji Balarabe. Zaria City, 1973. Total l., without strap, 74½ cm.
206. Straw hat, with decoration in leather by Alhaji Balarabe. Zaria City, 1973. w. 40 cm.

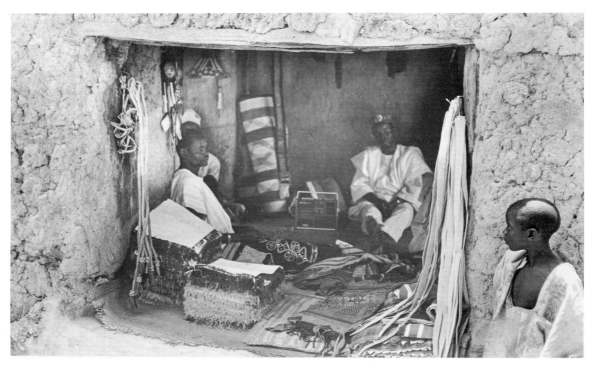

One of a line of mud-built market stalls in Kano City, where leatherwork and horse trappings are sold.

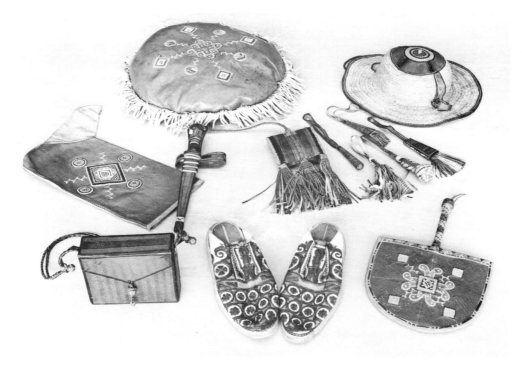

Leatherwork from Zaria and Kano.

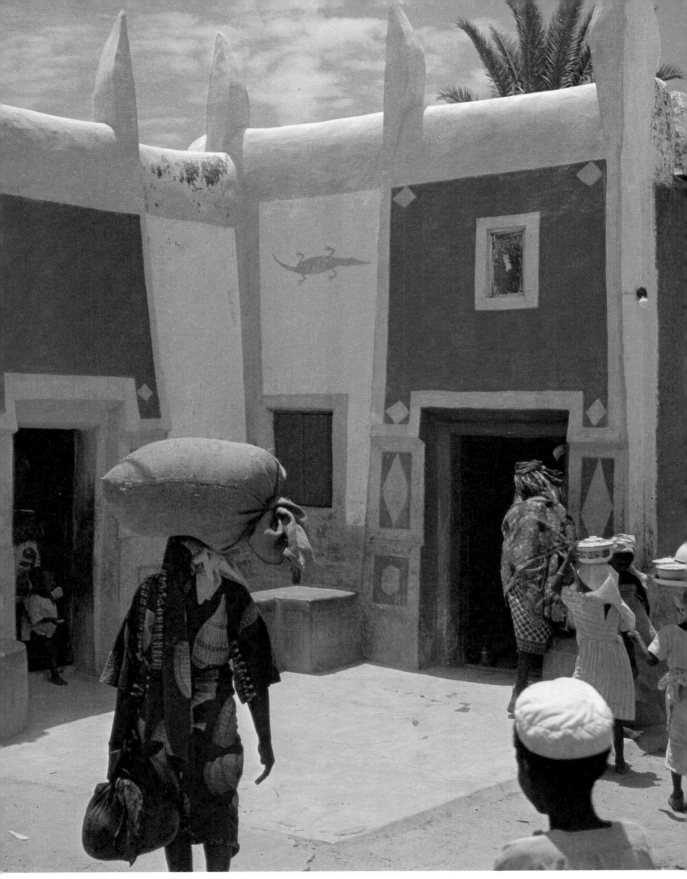

Plate 1. House on the road to the Na'Isa Gate. Kano City.

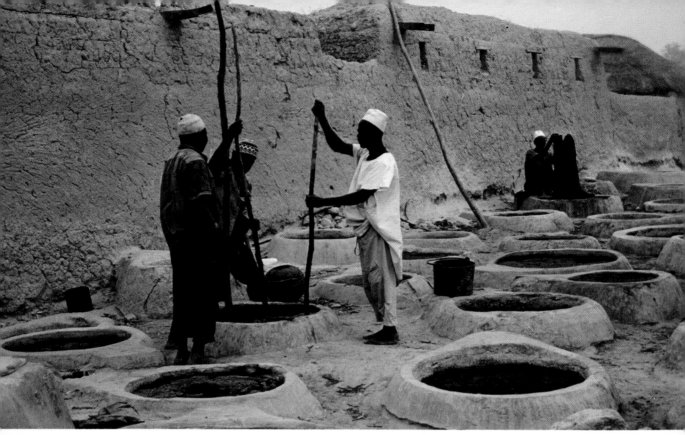

Plate 2. Dye pits in Zaria City.

Plate 3. Painting of footballers by Musa Yola. Cat. No. 31

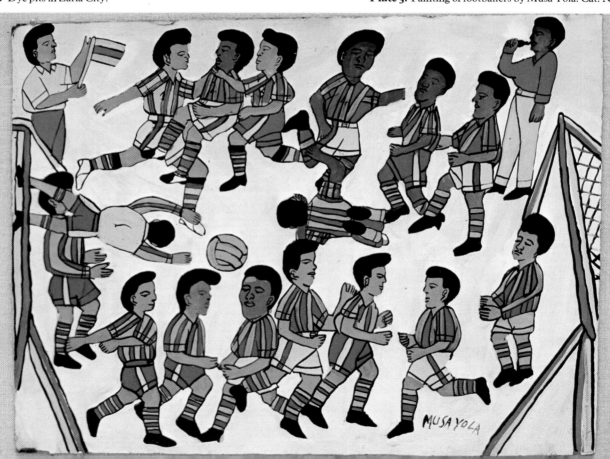

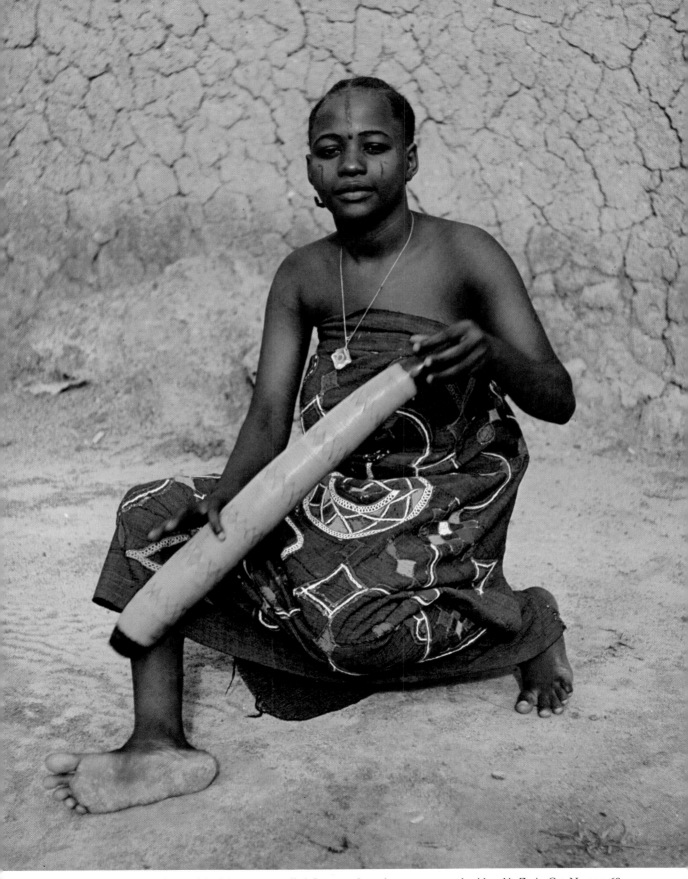

Plate 4. A woman of Zaria City playing a calabash instrument called *shantu*, and wearing a wrapper embroidered in Zaria. Cat. No. 302, 68.

Plate 5. Gown embroidered in Zaria with wild silk. Cat. No. 88.

Plate 6. Alhaji Sanni, an embroiderer, scholar and part-time builder, at the door of his workroom in the Yelwa district of Kano.

Plate 7. Interior of one of the princess's rooms in the Old Treasury, Kano. About 1930.

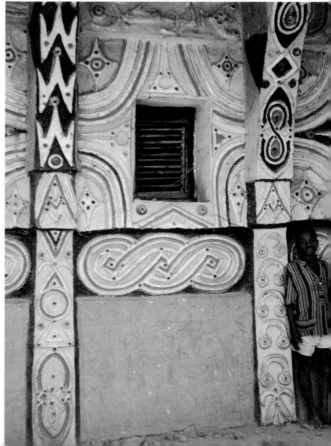

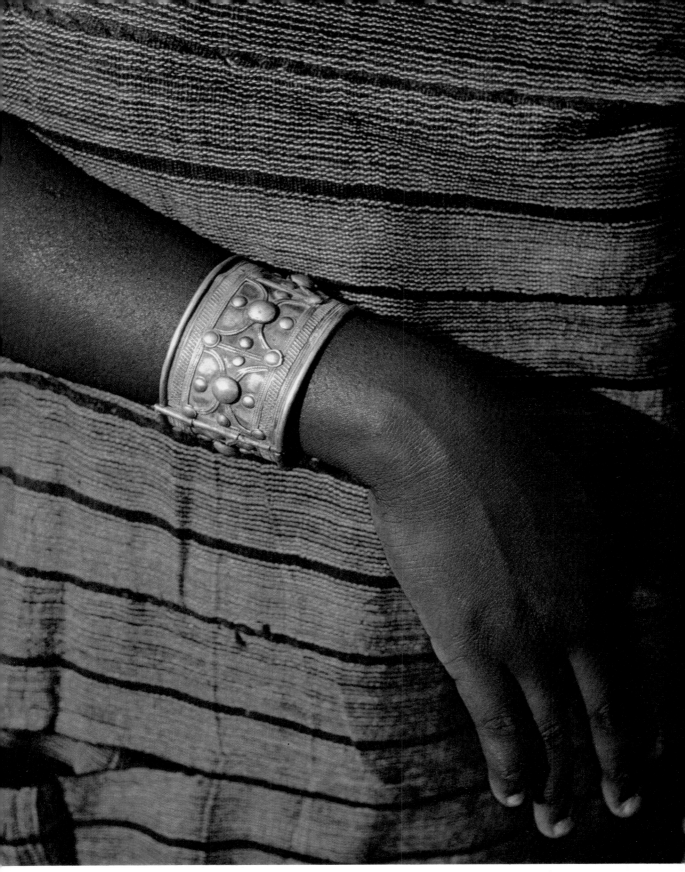

Plate 8. Hinged metal bracelet from Kano. Cat. No. 236.

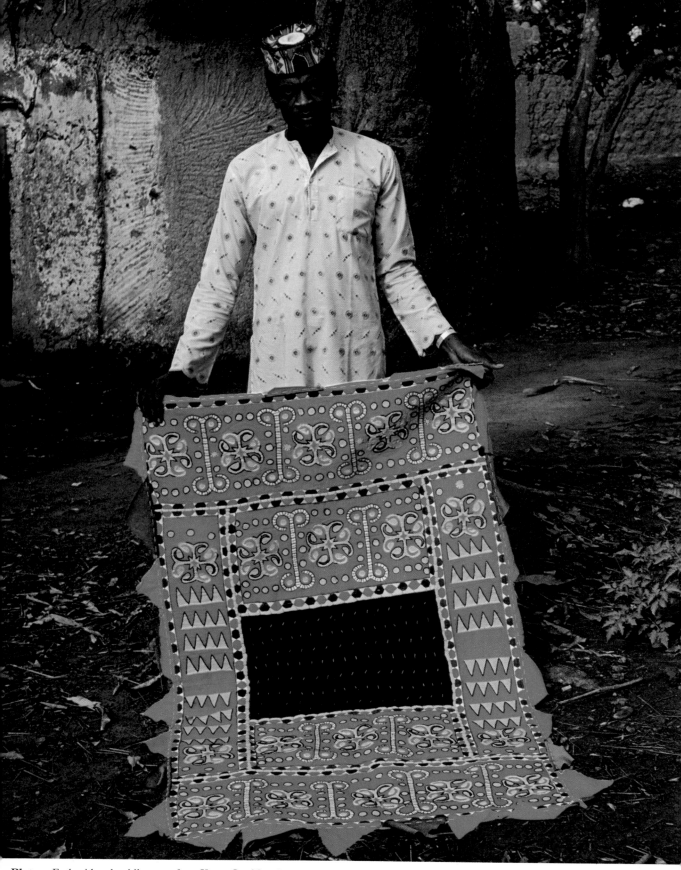

Plate 9. Embroidered saddle-cover from Kano. Cat. No. 283.

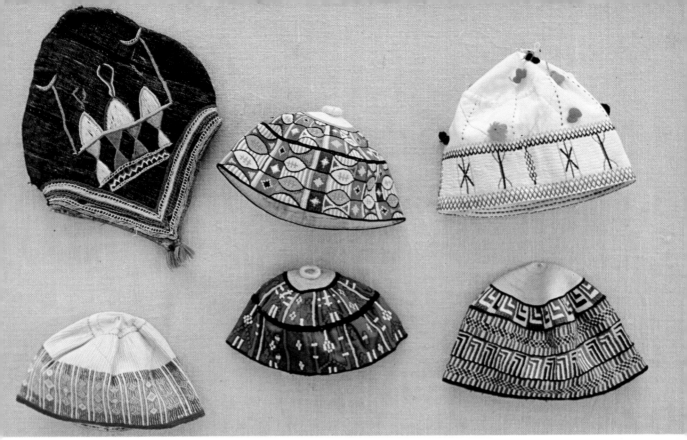

Plate 10. Embroidered caps from (top left) Dambatta and (top right) Kano. The four others are from Zaria City.

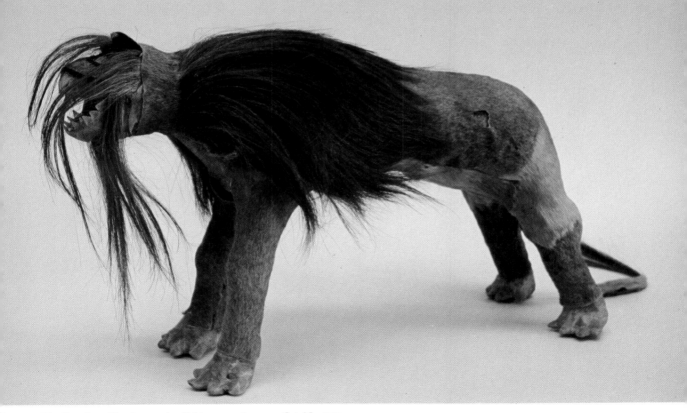

Plate 11. Toy lion, from Katsina, made of hide over a clay core. Cat. No. 327.

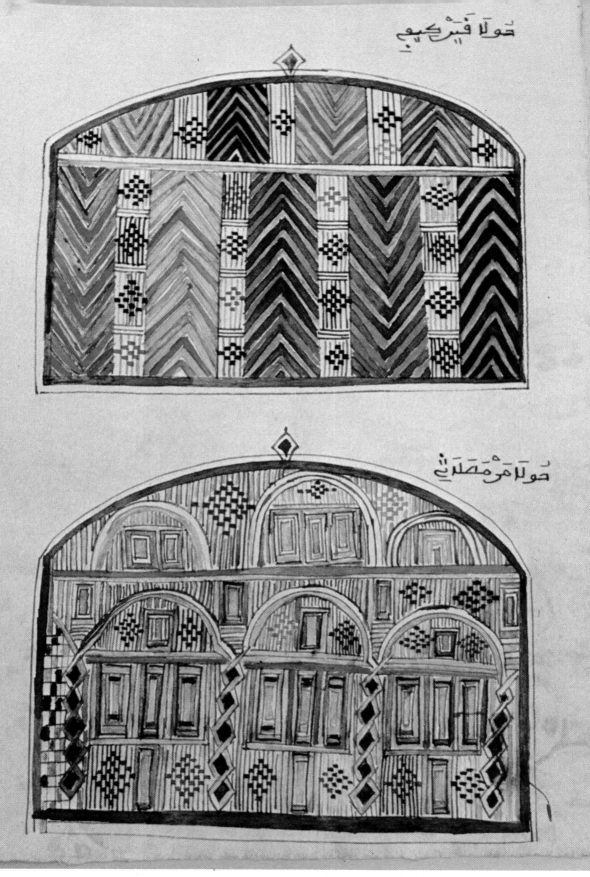

حولا فيركيبي

حولا مر مطري

Plate 12. Drawings of cap designs, in coloured inks, from Zaria. Cat. No. 15.

Metalwork

For over a thousand years until the beginning of the present century, iron was mined and worked in Hausaland. The introduction of scrap metal has brought this use of local ore to an end, and has coincided with a rapid decline in the production of many traditional metal articles, from city gates to oil lamps. The availability of cheaper, factory-made products has also contributed to radical changes that are still transforming the character of Hausa metalworking. Cold-smithing, which today makes use of kerosene tins, oil drums, and other discarded metal, has increased, while the demand for many products formerly made by the blacksmiths has ceased entirely. Yet although a great deal of the present cold-smithed work is quickly and rather roughly made, skill is by no means lacking, as is well illustrated by the ingenious modern wire baskets, used for holding food or burning charcoal.

Hausa blacksmiths still make some of their own tools, and others for a variety of craftsmen. Among them are awls and punches for leatherwork, needles for thatching, razors for barbers, adzes and axes for woodcarving, and arrows and traps for hunters. Blacksmiths also make farmers' hoes and sickles, musicians' trumpets, various attachments for horse trappings, and household equipment such as knives, scissors and tweezers.

The basic forms, and much ornamentation, of many of the older types of Hausa decorated metalwork were derived from foreign Islamic sources, some of the ideas arriving via the workshops of Nupe and Borno. The traditional Hausa methods of decoration include forging, in which metal is heated and beaten; *cire perdue*, in which it is melted and poured into a clay mould; chasing, whereby the surface of metal is punched and engraved, and *repoussé*, in which thin sheet metal is hammered from the back (or, in the case of counter-*repoussé*, from the front) to produce a raised design.

Most of the more elaborately decorated metal items included in the exhibition can still be made by some of the older Hausa smiths; but there is now little or no demand for them, and it is certain that as far as some are concerned it will soon be difficult to find anyone who knows anything much about them at all.

207. Decorated bowl with lid, used as a food container or for kolanuts. Katsina, before 1970. h. 21 cm.
208. Ring, silver-coloured, twisted, with chased decoration. Katsina, before 1975. w. 3½ cm.
209. Ring, undecorated. Katsina, 1975. w. 2½ cm.
210. Ring, copper-coloured. Katsina, 1975. w. 2 cm.
211. Ring, copper-coloured. Katsina, 1975. w. 2 cm.
212. Hinged bangle, brass-coloured. Jibiya, before 1974. w. 5½ cm.
213. Bangle or anklet, brass-coloured. Katsina, before 1973. w. 8 cm.
214. Bracelet, brass-coloured. Katsina, before 1974. w. 8½ cm.
215. Bracelet, silver-coloured. Katsina, before 1975. w. 6½ cm.
216. Metal knife. Katsina, 1975. l. 16½ cm.
217. Metal anklet, made by Usman Mai Balma. *Balma* is Hausa for 'Bilma salt', and Usman's family used to trade metal goods with the Tuareg for it. Katsina, before 1970. w. 11 cm.
218. Metal anklet. Katsina, before 1970. w. 9 cm.
219. Metal bracelet, made by Usman Mai Balma. Katsina, before 1974. w. 7 cm.
220. Metal bracelet (*munduwa*). Katsina, 1975. w. 6 cm.
221. Bracelet, brass-coloured, made by Malam Hassan. Katsina, 1975. w. 7 cm.
222. Bracelet, brass-coloured, made by Usman Mai Balma. Katsina, before 1974. w. 6 cm.
223. Bracelet, brass-coloured, made for a boy. Katsina, before 1975. w. 5 cm.
224. Earrings, of aluminium. Katsina, 1975. w. 2 cm.
225. Metal ring, with tenth-of-a-penny coin attached. Katsina, 1975. w. 2 cm.
226. Ring, brass-coloured. Katsina, before 1975. w. 2 cm.
227. Bracelet, or anklet, twisted-metal, silver-coloured. Probably Katsina, before 1975. w. 8 cm.
228. Brooch, of soldered metal. Zaria City, 1970. w. 4 cm.
229. Bracelet, of twisted, blackened metal. Zaria City, 1970. w. 6½ cm.
230. Decorated metal bowl with cover, known as *kumbu*. Such containers were once used for serving important people with milk and millet balls. Kano, before 1970. w. 22 cm.
231. Metal container for serving kolanuts to important people, referred to by a Kano smith as *gidauniya ta zuba goro*. Kano, before 1970. w. 28 cm.
232. Metal bell, made as part of a horse decoration. Kano, before 1970. w. 5 cm.
233. Wire basket, for holding food or fire. Sabon Gari, Zaria, 1975. w. 32 cm.
234. Hinged manilla. Kano, before 1970. w. 9 cm.
235. Ring, made by the *cire perdue* process, said to have been used by a hunter, presumably fixed to his bow as an arrow support. Kano, before 1974. w. 4 cm.
236. Metal bracelet. Kano, before 1974. w. 6 cm.
237. Water container (*shantali*), for ablutions. Kano, before 1960. h. 31 cm.
238. Two pairs of metal tweezers, for removing splinters, etc. Zaria City, 1975. l. 9 cm.
239. Metal bow, for the type of fiddle called *goge*. Decorated with chased patterning. It would have been strung with horsehair. Giwa, before 1974. l. 51 cm.
240. Metal bracelet, brass-coloured. Objects such as this are often referred to as '*manillas*', and some of the largest were used at times as a form of currency. From near Kano, before 1970. w. 8 cm.
241. Sword, with handle made by the Chief of the Blacksmiths. Zaria City, 1975. l. 95 cm.
242. Metal anklet. Sokoto, 1970. w. 9½ cm.

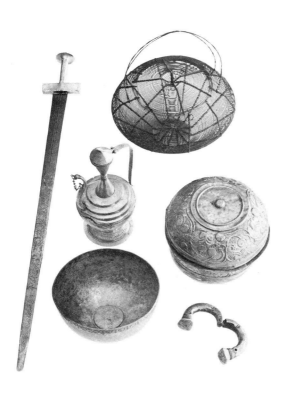

241, 233, 237, 207, 230, 234.
Metalwork: (left) sword; (top) metal basket; (centre)
ablutions kettle; (right) metal bowl and lid; (bottom left)
lower half of metal bowl; (bottom right) hinged bracelet.

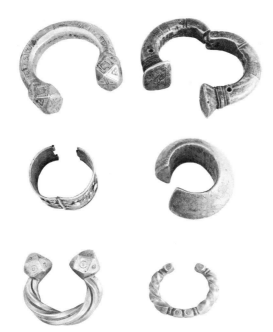

218, 234, 236, 242, 227, 214.
Bracelets, and anklets from (top) Kano, (centre) Kano and
Sokoto, and (bottom) Katsina.

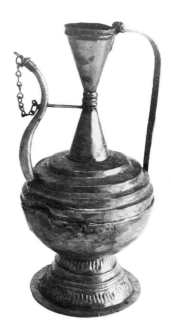

237. Ablutions kettle from Kano. The lid is not shown.

Pottery

A great deal of pottery is still made in Hausaland where, in contrast to most other parts of Africa, the work is done largely by the men. Although very handsome pots can be found, and the work of individual potters is sometimes outstanding, most Hausa pottery is made for purely practical purposes, and its appearance is more often simple than elaborate or subtle. However, special pots are made in some areas for inclusion in a girl's dowry, and these are colourfully decorated. Hausa pottery also tends to be less rigid where the women make it, as in the case of the pottery dolls from Argungu.

Like their counterparts in the rest of sub-Saharan Africa, the Hausa potters work without a wheel. Small items are made from a lump of clay turned in the hand, while larger pieces begin as a flat slab placed over the base of an upturned pot, or as a lump of clay placed in a shallow calabash or a hollow in the ground. In the latter situation the initial shape is beaten out with a pottery pestle.

Where a large piece of clay is being turned during the first shaping process and the potter is sitting on the ground he will often use one or both his feet to revolve it. Where he is standing to work he will walk around his pot, and for a finishing off process, such as the smoothing of a rim, he will circle it in one quick continuous movement.

Hausa pottery decoration is rarely elaborate, but strips of clay may be applied to create a decorative ridge, or knobs and bosses may be added. Designs are also incised with sharp tools, or are impressed, using twigs, or roulettes of twisted or plaited fibres. These are rolled over the clay surface while it is still damp to produce bands of pattern. Tone and colour contrast are achieved with clay slip or laundry blue, painted on with a feather or a piece of cloth tied to a stick. Decomposed mica-schist burnished with baobab seeds produces a golden sheen, and a dark red liquid made by boiling locust-bean pods in water is employed to create a varnish-like effect not unlike a glaze. However, glazes are never achieved with the comparatively low temperatures to which Hausa pottery is fired.

Firing takes place in the open, and though there are potters who fire inside low-walled enclosures with holes for inserting fuel, there are no true kilns. Preparations for a typical firing begin with a layer of grass being placed over the ashes of the previous firings. Brushwood is laid on top of this and the pots are then arranged from the centre, with, where possible, the base of one pot set into the mouth of the next. The work of the individual potters is sometimes kept separate, and each man then arranges his work in his own allotted

space. The women's pots, which are made in the seclusion of the family compound, are brought out, arranged, and fired for them.

The completed heap of pottery is covered with fuel, which varies to some extent according to what is available. Usually it is grass, brushwood, grain stalks and donkey dung. Water and ashes are sprinkled on the heap before, and sometimes even after, the firing begins, in order to slow down the rate of burning. Occasionally, by a reduction of flame, a black type of pottery is produced, but most Hausa pots are reddish or golden in colour. The actual firing, preceded by a prayer (*Bismallah ir-rahman ir-rahim*: in the Name of God, the Merciful, the Compassionate), lasts anything from fifteen minutes to several hours. It normally takes place in the late afternoon, to avoid excessive wind, and most of the pots are removed the next morning, when they have had time to cool.

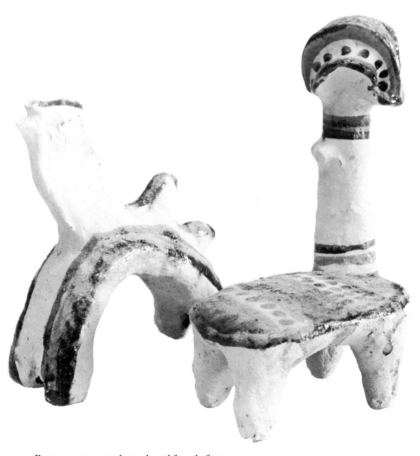

247. Pottery toys: camel, stool, and female figure.

243. Ablutions jug (*buta*). Funtua, 1975. h. 17 cm.

244. Ablutions jug (*buta*). The blind spout is very unusual. Bauchi, 1975. h. 21 cm.

245. Tobacco-pipe bowl. Zaria City, 1974. l. 9 cm.

246. Tobacco-pipe bowl. Zaria City, 1974. l. 5 cm.

247. Eight pieces of pottery sculpture made for children, and painted with clay slip, dye and gum. Five represent female figures, each with a distinct hairstyle, two are camels, and one is a stool. They are made by women, and are apparently a long-established product. Argungu, 1975. h. 15 cm.

248. Ablutions jug (*buta*). Cheranchi, 1975. h. 18 cm.

249. Spherical water pot. Katsina, 1975. h. 32 cm.

250. Water cooler (*randa*), coated with decomposed mica-schist, made by Malam Idi Katsina. Hunkuyi, 1974. h. 51 cm.

251. Water cooler (*randa*), coated with decomposed mica-schist, made by Malam Idi Katsina. Hunkuyi, 1974. h. 42 cm.

252. Ablutions jug (*buta*). Kura village, 1975. h. 23 cm.

253. Ablutions jug (*buta*). Kura village, 1975. h. 21 cm.

254. Spherical water pot. Jibiya, 1975. h. 42 cm.

255. Black cooking pot, burnished before firing. From near Kano, 1974. w. 30 cm.

256. Water cooler. Zaria City, 1975. h. 41 cm.

257. Water cooler, coated with decomposed mica-schist, made by Malam Idi Katsina. Hunkuyi, 1974. h. 31 cm.

258. Spherical water pot. From near Kano, 1974. h. 38 cm.

259. Spherical water pot, with decoration made by a woman. From near Kano, 1974. h. 36 cm.

260. Water cooler, coated with decomposed mica-schist, made by Malam Idi Katsina. Hunkuyi, 1974. h. 39 cm.

261. Ablutions jug. Kano, 1975. h. 16 cm.

262. Ablutions jug. Kura village, 1975. h. 20 cm.

263. Coin bank (*banki*). Kano, 1975. h. 14 cm.

264. Small pot (*tukunya*). Kano, 1975. h. 7 cm.

265. Spherical water pot. Jibiya, 1975. h. 29 cm.

266. Ablutions jug. Kura, 1975. h. 21 cm.

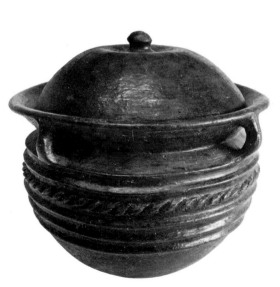

255. Black cooking pot from near Kano.

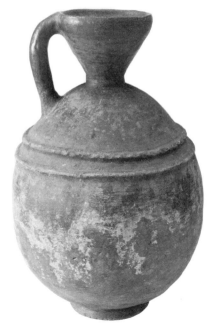

256. Water cooler from Zaria City.

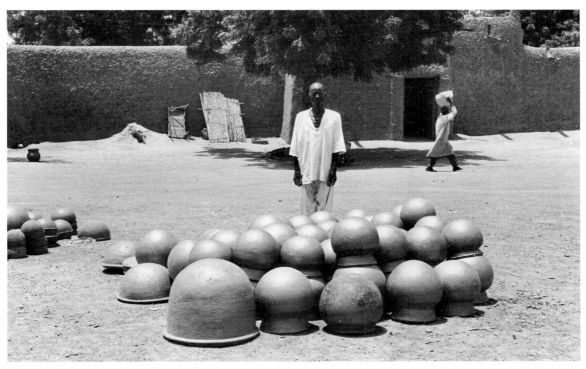

A Kano potter with his work.

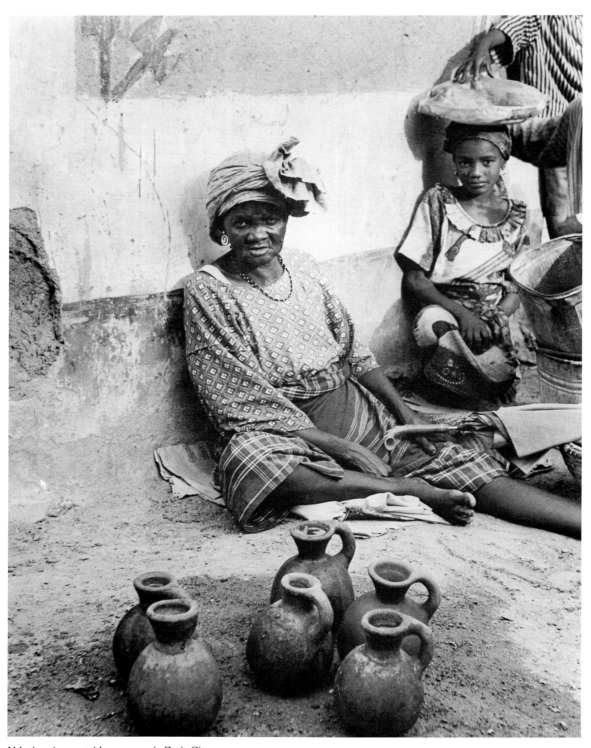

Ablutions jugs outside a mosque in Zaria City.

Woodcarving

Most Hausa woodcarving is carried out in the rural areas, and the range of articles made is still considerable. It includes hoe, axe, and adze handles, shuttles and spindles, food bowls, stools, pestles and mortars, musical instruments, yokes and saddles, tethering posts, canoes, and Quranic writing boards.

A Hausa carver's tools are simple, and he does most of his work with little more than an axe and an adze. The wood he uses is selected according to what is going to be made; gutta-percha (*ganji*), for instance, is preferred for cylindrical drums, tamarind for axe handles, shea (*ka'de*) for tethering posts and pestles, copaiba balsam (*maje*) for mortars, African rosewood (*madobiya*) for weavers' rods (beaters), and silk-cotton for canoes.

The articles that are most frequently decorated are stools and food bowls. Linear patterns are carved on them, or burnt in with hot metal tools. An effect of tonal contrast is also achieved by scorching selected areas of the surface. Black stain, and occasionally, in the case of the stools, a little colour, is also used.

There is no figurative woodcarving among the Muslim Hausa. Occasionally a scarecrow is made of wood, but such figures are always extremely rudimentary.

267. Food bowl. Katsina, 1975. w. 29 cm.
268. Food bowl. Zaria area, before 1974. w. 30 cm.
269. Stool. Kano, before 1973. h. 13 cm.
270. Stool. Jibiya, before 1974. h. 18 cm.
271. Woodcarver's adze. Katsina, 1974. l. 32 cm.
272. Stool. Cheranchi, before 1975. h. 14 cm.
273. Stool. Katsina, before 1975. h. 16 cm.
274. Stool. Jibiya, before 1974. h. 14 cm.
275. Stool. Jibiya, before 1974. h. 16½ cm.
276. Stool. Jibiya, before 1975. h. 13 cm.
277. Food bowl. Zaria area, 1973. w. 24 cm.
278. Stool. Hadejia, 1974. h. 20 cm.

279. Small mortar, used for crushing kolanuts in the market. Zaria City, 1975. h. 18½ cm.
280. Small pestle, for use with the mortar (no. 279). Zaria City, 1975. l. 45 cm.
281. Eleven-legged stool. Kudan village, 1973. h. 23 cm.
282. Three hip girdles, made of discs of wood. They are worn by women under the clothes to accentuate the hips. Kano, before 1974. Average l. 80 cm.
282a. Two small spoons. From near Kano, 1975. l. 15 cm.

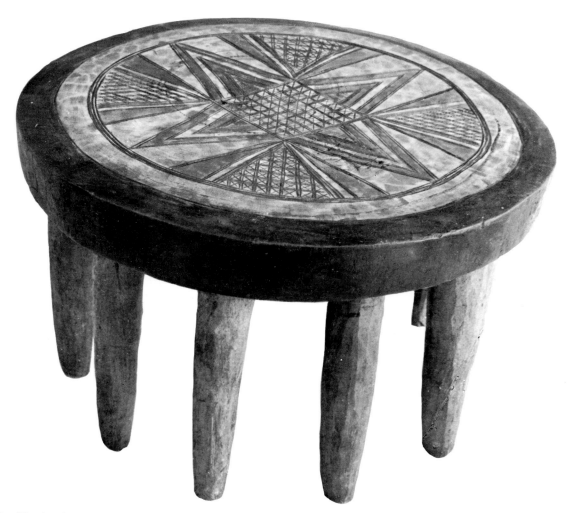

281. Wooden eleven-legged stool from Kudan village.

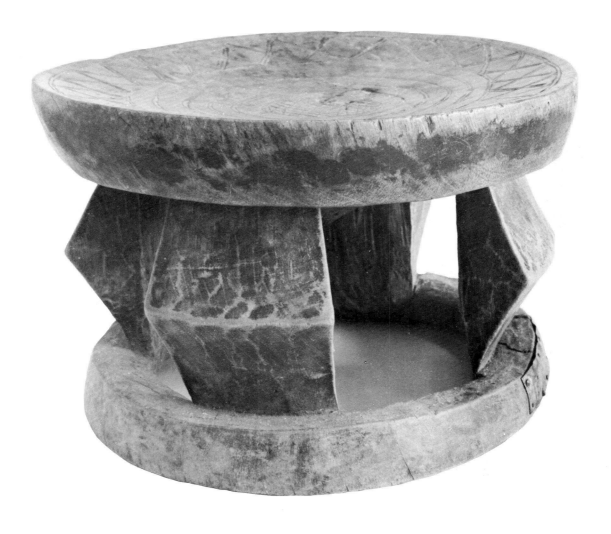

Wooden stool from Jibiya.

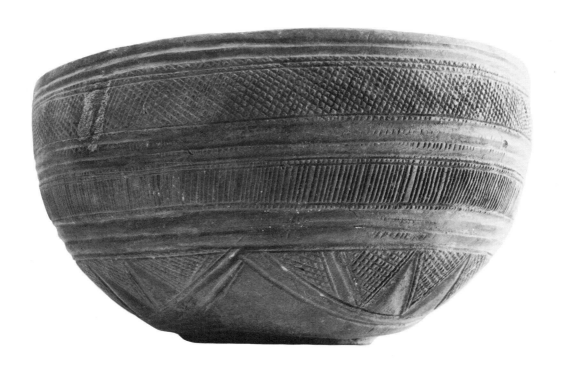

Wooden food bowl from Kudan.

Horse Trappings

Horse trappings combine products from several crafts: leatherwork, woodcarving, metalwork, embroidery and weaving. They are one of the most spectacular aspects of Hausa art, and they have a great deal in common with the work of the Tuareg and the Kanuri. They appear in all their splendour in the parades held for visiting dignitaries and on certain religious feast days. Some of the best horse trappings are made in Kano, and all the items included in the exhibition, apart from the pommel cover from Zaria and the saddle-cloth from Zinder, were collected in Kano Market on the same day in 1975.

283. Embroidered saddle-cloth. Kano, 1975. l. 151 cm.

284. Embroidered saddle-cloth. Zinder, 1970. l. 123 cm.

285. Two plaited neck ornaments (*gurun wuya*). Kano, 1975. l. 40 cm.

286. Reins. Kano, 1975. l. 180 cm.

287. Reins. Kano, 1975. l. 153 cm.

288. Reins. Kano, 1975. l. 180 cm.

289. Face ornament (*'dan ka*). Kano, 1975. l. 50 cm.

290. Girth strap (*majayi*). Kano, 1975. l. 154 cm.

291. Girth strap. Kano, 1975. l. 144 cm.

292. Girth strap. Kano, 1975. l. 160 cm.

293. Halter. Kano, 1975. l. 57 cm.

294. Forehead ornament (*'dan goshi*). Kano, 1975. l. 35 cm.

295. Forehead ornament (*'dan goshi*). Kano, 1975. l. 50 cm.

296. Forehead ornament (*'dan goshi*). Kano, 1975. l. 32 cm.

297. Neck ornament (*gurun wuya*). Kano, 1975.

298. Halter. Kano, 1975. l. 60 cm.

299. Halter. Kano, 1975. l. 66 cm.

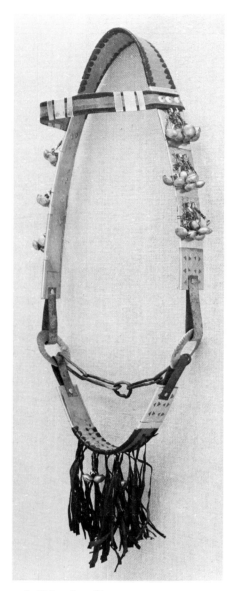

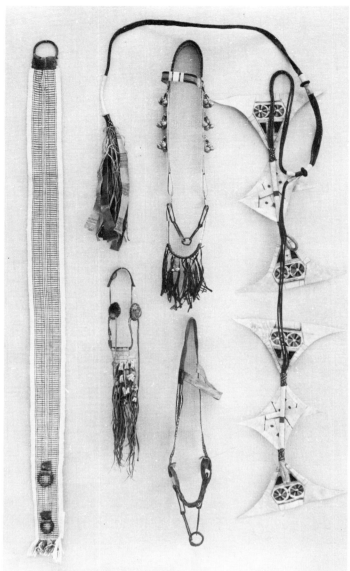

298. Halter from Kano.

Horse trappings from Kano. From left to right they are a girth, a face ornament, two halters, and a pair of reins.

Musical Instruments

Most instrumental music in Hausaland is secular, professional, and made by men. Hausa musicians are treated rather like craftsmen, and they have a low status, though some of them are nevertheless very rich. Impromptu music, for the pleasure of making it, is usually performed only by children, who use simple instruments such as corn-stalk pipes, or by the women, who play the calabash *shantu*, the Jew's harp, and percussion instruments such as calabashes, or domestic wooden mortars, with which several women can make effective pounding rhythms.

There is a great variety of Hausa musical instruments, some of them clearly derived from Arabic types. The examples included in the exhibition indicate only a part of the whole range. Some are extremely attractive objects, and no other area of Hausa artistic activity uses so many different materials. These include various woods and vegetable fibres, the skins of several types of animal, iron for gongs and fiddle bows, brass and aluminium for trumpets, and even sardine tins for one particular type of stringed instrument. Antelope horns are blown and used as gong beaters. Calabashes are made into drums and are also employed as trumpets, rattles and sound boxes. The list of materials is endless, for any suitable thing may be pressed into service, from groundnut oil and peppers to cowrie shells, printed cloth, buttons and nails, either as part of an instrument's structure, for preserving it or for controlling its tone.

300. Oboe, or shawm. Kano, 1975. l. 50 cm.

301. Kettle drum (*taushi*), formerly played by the drummer Muhammed 'Dan Daku of Sokoto, who performed in a group of five drummers. Sokoto, before 1974. w. 21 cm.

302. Calabash aerophone, known as *shantu*. It is open at both ends and played by women, who strike it against a leg and the palm of a hand and produce a soft thudding rhythm, usually to accompany a song. Sokoto, 1974. l. 58 cm.

303. Hour-glass-shaped drum of wood, skin and leather, with a curved drumstick. Zaria City, 1975. l. 33 cm.

304. Spike-bowl lute, called *molo*. Zaria City, 1975. l. 49 cm.

305. Trumpet, called *kakaki*, the wide end made of brass from an imported decorative object, possibly a tray. This is a small version of the trumpets played for the Emirs. Zaria City, 1975. l. 143 cm.

306. Three Jew's harps, each with a plaited, ornamental leather strip. They are played by women. Zaria City, 1975. l. 4 cm.

307. Hour-glass-shaped drum. Zaria City, 1975. l. 36 cm.

308. One-stringed, spike-bowl lute (*goge*), and bow. Zaria City, 1975. l. 66 cm.

309. Two-stringed, spike-bowl lute (*garaya*). Zaria City, 1975. l. 113 cm.

310. One-stringed, spike-bowl lute (*goge*). Giwa, before 1975. l. 61 cm.

311. Double gong of iron. Such gongs are usually struck with an antelope horn and once accompanied armies into battle. Sokoto area, before 1970. l. 27 cm.

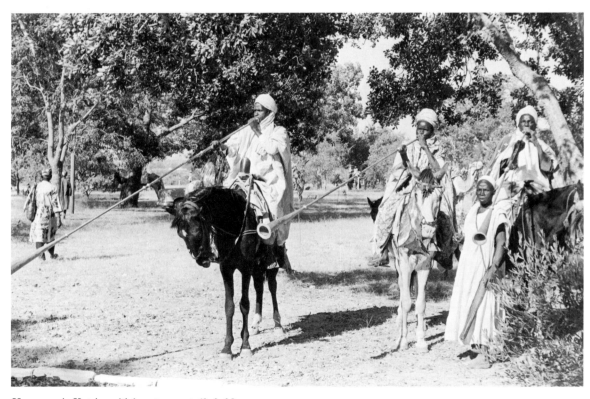

Horsemen in Katsina with long trumpets (*kakaki*).

Miscellaneous Items

312. Oil painting showing Hausa musicians and two groups of dancers, by Musa Yola. Zaria, 1971. 92 × 76 cm.
313. Oil painting showing footballers against a white background, by Musa Yola. Zaria, 1971. 92 × 70½ cm.
314. Oil painting showing figures in white against a green ground, by Musa Yola. Zaria, 1971. 91½ × 61 cm.
315. Oil painting of a cyclist, by Musa Yola. Zaria, 1971. 91½ × 16 cm.
316. Oil painting of women's hairstyles, by Musa Yola. It is similar in layout to the barbers' and hairdressers' signs common in many urban centres in Nigeria. Zaria, 1971. 82 × 56½ cm.
317. Oil painting of footballers, by Musa Yola. Zaria, 1971. 85 × 61 cm.
318. Oil painting including, in the top section, helmeted soldiers, by Musa Yola. Zaria, 1971. 80 × 61 cm.
319. Oil painting of footballers and other figures against a red ground, by Musa Yola. Zaria, 1971. 91½ × 61 cm.
320. Stick toy that expands with a scissors motion, the end furthest from the operator adorned with a bird's skull. Cheranchi, 1975. w. 54 cm.
321. Small container for butter, called *tandu* and made of hide. Katsina, 1975. l. 18 cm.
322. Small container for tobacco or snuff, called *batta* and made of hide, with scratched decoration. Katsina, 1975. l. 11 cm.
323. Plain container for tobacco or snuff, called *batta*. Jibiya, 1975. l. 10 cm.
324. Three-legged container for antimony used as a cosmetic, called *tandu* and made of hide. Zaria City, 1975. l. 10 cm.
325. Two containers for antimony used as a cosmetic, called *tandu* and made of hide. l. 8 and 6 cm.
326. Toy hyena with a bone in its mouth, made of hide over a clay core. Katsina, 1975. l. 12 cm.
327. Toy lion, made of hide over a clay core. Katsina, 1973. l. 36 cm.
328. Toy lorry, made of rubber by a shoemaker. Katsina, 1973. l. 25 cm.
329. Toy motor scooter, made of rubber. Katsina, 1973. l. 12 cm.
330. Toy motor scooter, made of red rubber. Katsina, 1973. l. 14 cm.
331. Toy motor scooter, made of rubber. Katsina, 1973. l. 18 cm.
332. Decorative plaited sword sling. Kano, 1975. l. 137 cm.
333. Decorative plaited sword sling. Zaria City, 1975.

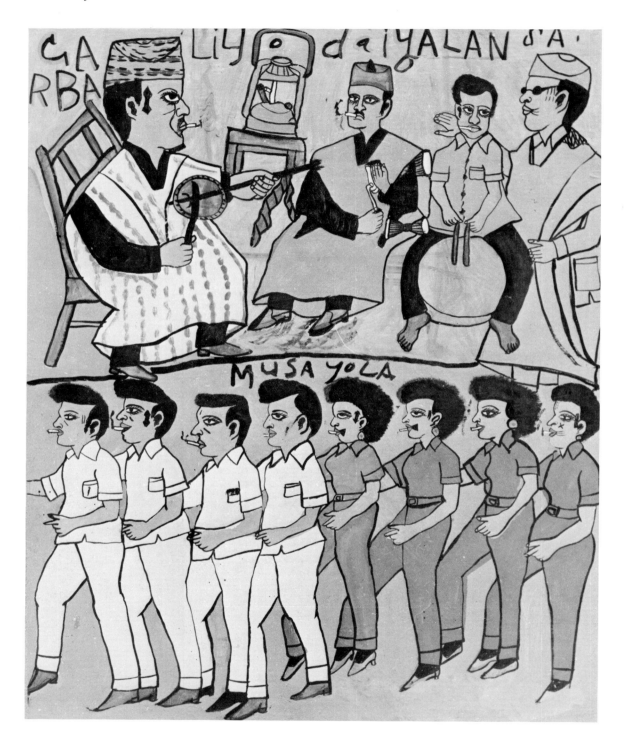

312. Painting by Musa Yola of dancers and a group of musicians led by Garba Liyo.

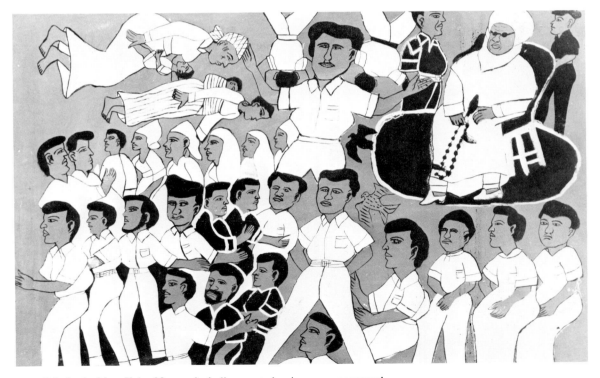

314. Painting by Musa Yola of figures, including a seated emir, on a green ground.

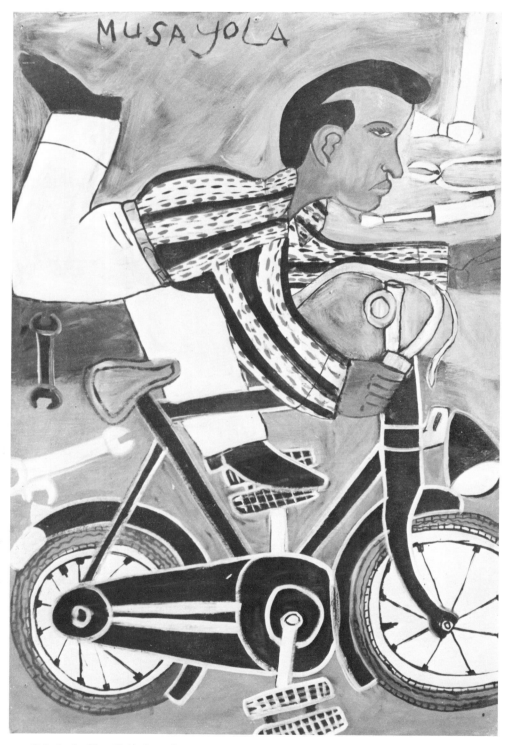

315. Painting by Musa Yola of a cyclist.

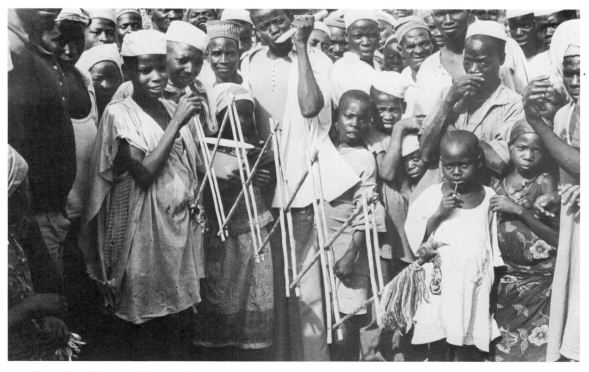

320. Expanding stick toy, in Cheranchi Market.

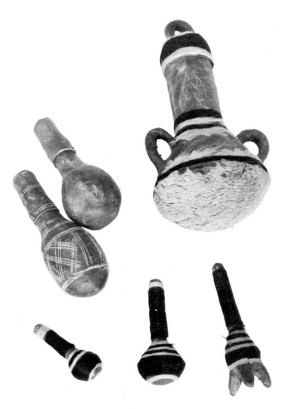

321, 324, 325, 322, 321.
Containers made of hide, for oil, tobacco, and antimony.
Their numbers, clockwise from the top right, are
321, 324, 325, 322, 321.

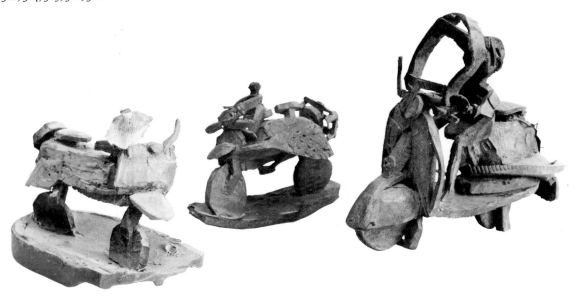

329, 330, 331. Three toy motor scooters made of rubber.

Wall Decoration

The climate of Hausaland is dry for much of the year, so that mud buildings can be easily maintained and elaborate mud architecture and ambitious wall decoration have reached a high level of development. The earliest Muslim Hausa wall decoration probably began as restrained and rather geometrical work that arose in an almost unpremeditated fashion from established techniques used for building with mud. One such effect, much in evidence throughout Hausaland, is a pattern of parallel, curved lines that results from the natural movement of a builder's hand in applying mud plaster.

The elaborate ornamentation of exterior walls, incorporating representational motifs such as those of lorries, bicycles, guns, animals and people, drew some of its initial inspiration from the more geometrical types of decoration that had already been made for interiors, the best example of which is the nineteenth-century Zaria City Mosque, undoubtedly the finest mud building in Hausaland. Outstanding later examples of interior decoration include portions of the Emir of Kano's Palace and a number of related buildings, also in Kano. One of these was once used as the Kano Treasury, and the walls of two of its rooms, which were private apartments, were covered in the 1930s with polychrome relief ornament in an elaborate style transitional between the early restrained and the later exuberant work. It included both secular and religious symbols, such as spears, guns, ablutions kettles and Quranic writing boards.

The rapid development of exterior decoration that took place from the 1940s to the 1960s was largely the work of men living in Kano and Zaria. Many of those in Kano also travelled to other places, such as Zinder, Katsina, and even Zaria, to carry out commissions, and the new style coincided with a more general use of factory-made cement, which for those who could afford it replaced locally made *laso* as a protective layer for exterior mud surfaces. Its strength and appearance encouraged wall-decorators to undertake far more ambitious projects, since it provided not only long-term protection but also an attractive finish for their work.

Although some of the established Hausa ornamental motifs, and techniques such as the embedding of coloured enamelware into a wall or ceiling, have come from foreign sources, Hausa builders have also made their own special contributions. These have arisen partly out of demands by house owners (many of whom were wealthy traders) for new and striking designs, and partly from a desire on the part of the builders themselves to be original. As a result a number of delightful works of art have been created.

However, since the mid-1960s there has been a general withdrawal from the more adventurous type of decoration that was produced particularly in Zaria, and more conventional ornamentation has again become popular, with a preference for plasterwork in which damp cement is cut and scraped and then often painted, giving a repetitive, all-over effect. Plant shapes used as basic motifs repeated within an irregular chequer-board pattern are common in this kind of work, which is often used for covering entire walls.

The latest stage, consisting of a free use of painted decoration, was initiated in the 1960s by Musa Yola, who remains its chief exponent. He began by using a plaster technique to which he has occasionally returned, though he now works exclusively with paint, using a wall in the same way that many painters today use a canvas: as a flat surface over which he can distribute the fruits of his extraordinarily fertile imagination.

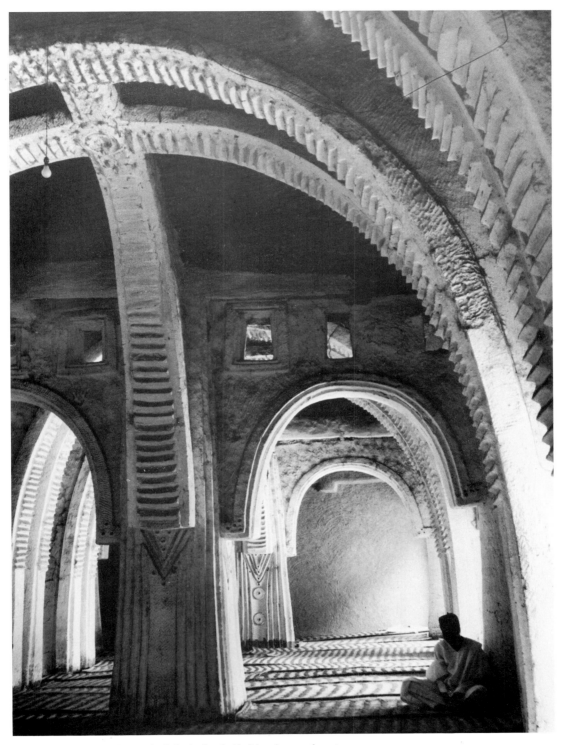

Interior of Zaria City Mosque, built in the first half of the nineteenth century.

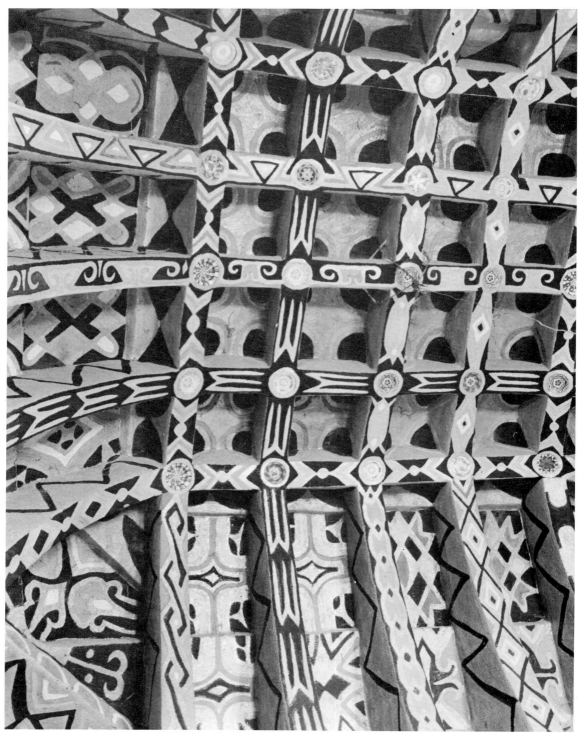

Ceiling decoration in the Emir of Kano's Palace.

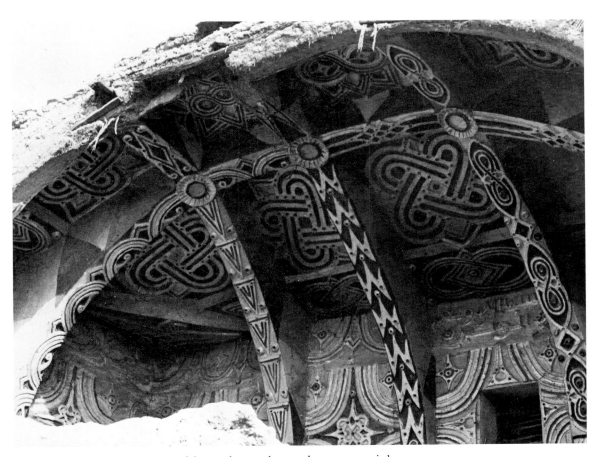

Interior of Kano Old Treasury: one of the two decorated rooms that were occupied
by a Kano princess. About 1930.

The house of Alhaji Muhammadu, Tudun Wada, Zaria.
About 1960.

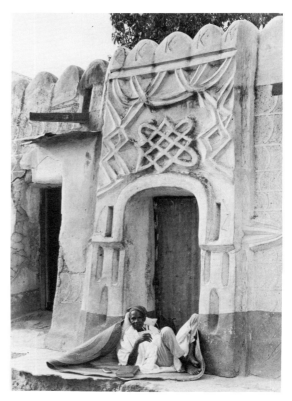

The house of Malam Suluki, Tudun Wada, Zaria.
About 1960.

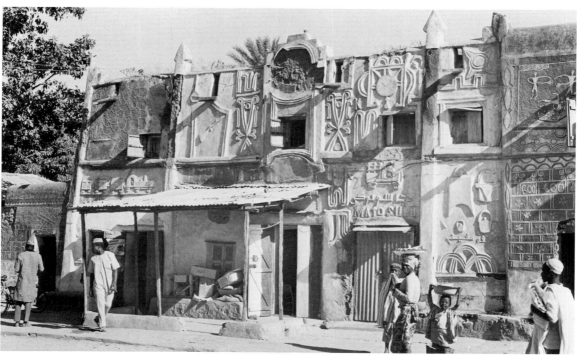

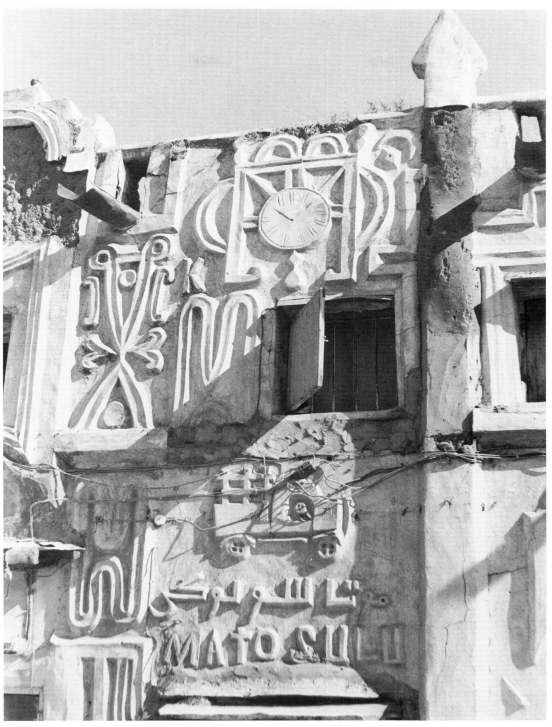

Malam Suluki's house, Tudun Wada, Zaria. The inscription, in both Arabic and
English, is intended to read '*motan Suluki*' (Suluki's lorry).

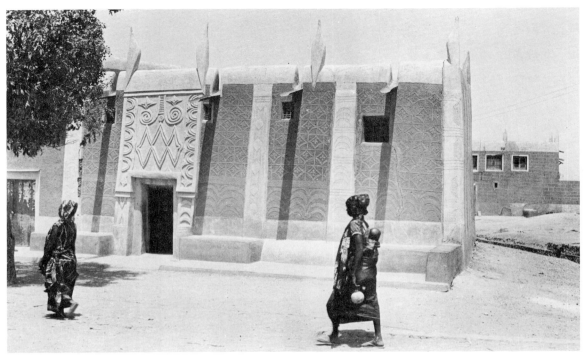

House decoration in Katsina. About 1970.

The Emir of Zaria's Palace. It is regularly repainted.

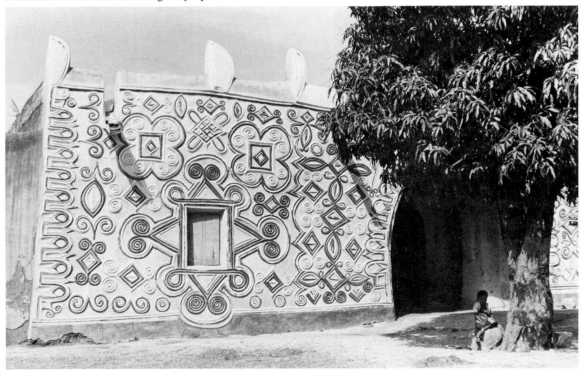

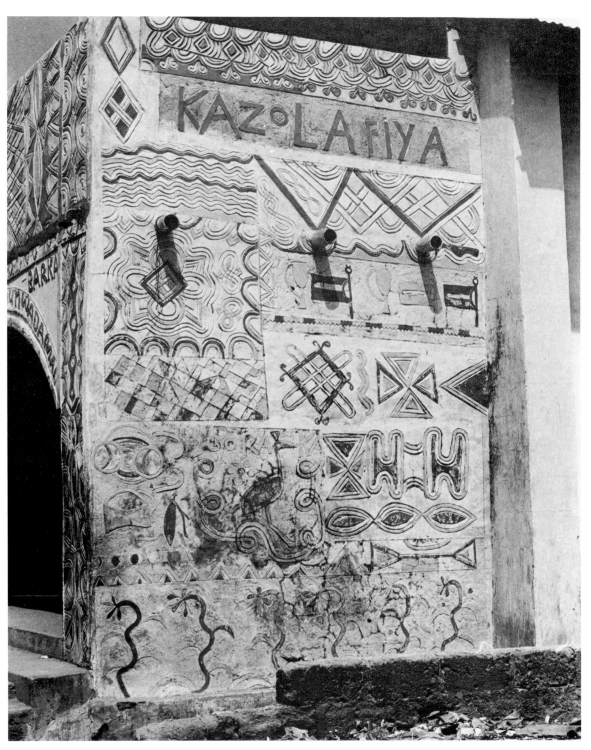

Modern decoration on the Albarka Cinema, Zaria.

A detail of the decoration on the Albarka Cinema, Zaria.

Recent decoration on a clock repairer's house in Zaria City.

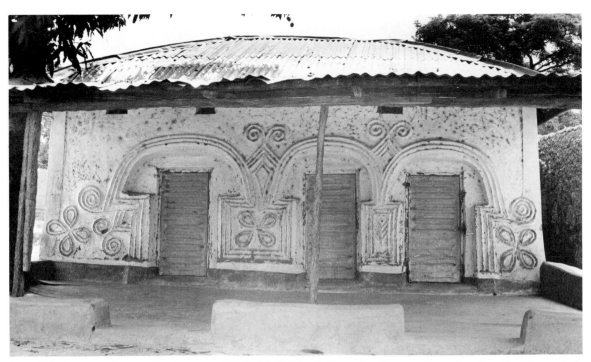

A small Zaria mosque decorated by the present Chief of the Builders in Zaria City. He comes from a long line of builders, one of whom, Babban Gwani, built the old Zaria City Mosque.

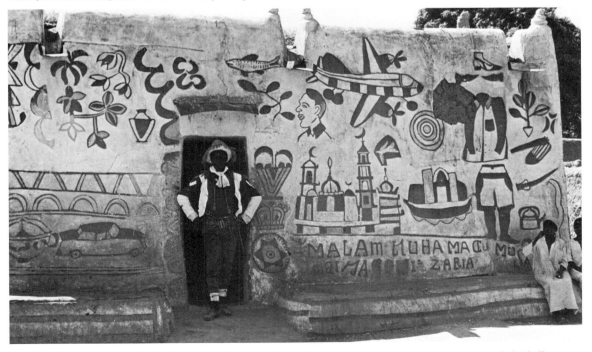

Musa Yola photographed in Zaria City in 1972 with one of his earliest pieces of wall decoration, on the house of a herbalist, Malam Muhammadu.

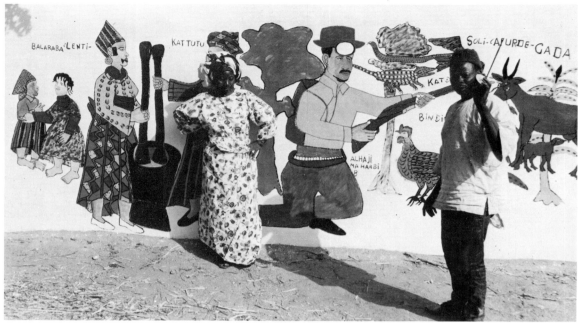

Musa Yola in 1973 decorating a wall of Alhaji Abashiya's compound in Hunkuyi. Alhaji Abashiya's wife Kattutu is standing in front of her portrait.

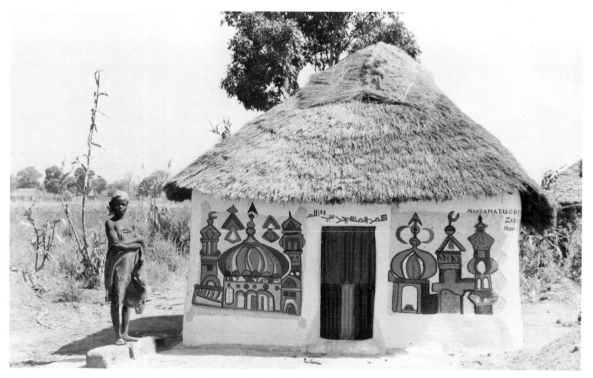

A design representing the modern Kano Mosque, painted by Musa Yola on a mosque belonging to Alhaji Abashiya of Hunkuyi. 1973.

Bibliography

The following selected list contains, first, publications on various aspects of Hausa art and music; second, others that are only partly or indirectly concerned with the subject, and third, those dealing with other aspects of Hausaland. Following this there is a list of dictionaries and a note on recorded Hausa music.

THE ARTS OF THE HAUSA

Ames, David W. 1965. 'Hausa drums of Zaria', *Ibadan*, No. 21, pp. 62–79.

Ames, David W. 1968. 'Professionals and amateurs: the musicians of Zaria and Ibimo', *African Arts/Arts d'Afrique*, Vol. I, No. 2 (Winter), pp. 40–45, 80, 82–84.

Ames, David W. 1970. 'Urban Hausa music', *African Urban Notes*, Vol. V, pp. 19–24.

Ames, David W. 1973. 'Igbo and Hausa musicians: a comparative examination', *Ethnomusicology, Journal of the Society of Ethnomusicology*, Vol. XVII, No. 2 (May).

Ames, David W. 1973. 'A sociocultural view of Hausa musical activity', *The traditional artist in African society*, ed. Warren d'Azevedo. Bloomington: Indiana University Press.

Ames, David W., Gregersen, E. A. and Neugebauer, T. 1971. '*Taaken Samaarii*: a drum language of Hausa youth', *Africa*, Vol. XLI, pp. 12–31.

Ames, David W. and King, Anthony V. 1971. *Glossary of Hausa music and its social contexts*. Evanston: Northwestern University Press.

Balfour, Henry. 1934. 'The *tandu* industry in Northern Nigeria and its affinities elsewhere', *Essays presented to C. G. Seligman*, ed. E. E. Evans-Pritchard, R. Firth, B. Malinowski and I. Shapera. London: Kegan Paul, Trench, Trubner, pp. 5–18, pls. 1–5.

Beier, Ulli. 1962. 'Nigerian folk art', *Nigeria*, No. 75 (December), pp. 26–32.

Bivar, A. D. H. 1964. *Nigerian panoply: arms and armour of the Northern Region*. Lagos: Department of Antiquities.

Campbell, M. J. 1959. 'The walls of a city', *Nigeria*, No. 60, pp. 39–59.

Daniel, F. de F. 1932. 'The regalia of Katsina, Northern Province, Nigeria', *Journal of the African Society*, Vol. XXI, No. 122 (January), pp. 80–83.

Elliott, H. P. 1940. 'Mud building in Kano', *Nigeria*, No. 20, pp. 275–278.

Goddard, A. David. 1970. 'Industry', *Zaria and its region*, ed. M. J. Mortimore. Zaria: Ahmadu Bello University, Department of Geography, Occasional Paper No. 4, pp. 170–182.

Harris, P. G. 1932. 'Notes on drums and musical instruments seen in Sokoto Province, Nigeria', *Journal of the Royal Anthropological Institute*, Vol. LXII, pp. 105–125.

Heathcote, David H. 1972. 'Hausa embroidered dress', *African Arts*, Vol. V, No. 2 (Winter), pp. 12–19, 82, 84.

Heathcote, David H. 1972. 'A Hausa embroiderer of Katsina', *The Nigerian Field*, Vol. XXXVII, No. 3 (September), pp. 123–131.

Heathcote, David H. 1972. 'Some Hausa lizard designs', *Embroidery*, Vol. XXIII, No. 4 (Winter), pp. 114–116.

Heathcote, David H. 1972. 'Insight into a creative process: a rare collection of embroidery drawings from Kano', *Savanna*, Vol. I, No. 2 (December), pp. 165–174.

Heathcote, David H. 1973. 'Hausa women's dress in the light of two recent finds', *Savanna*, Vol. II, No. 2 (December), pp. 201–217.

Heathcote, David H. 1973. 'The princess's apartments in Kano Old Treasury', *Savanna*, Vol. II, No. 1 (June), pp. 61–65.

Heathcote, David H. 1973. 'A selection of Hausa children's fashions', *The Nigerian Field*, Vol. XXXVIII, No. 3 (September), pp. 99–113.

Heathcote, David H. 1974. 'The art of Musa Yola'. *African Arts*, Vol. VII, No. 2 (Winter), pp. 34–37.

Heathcote, David H. 1974. 'Aspects of style in Hausa embroidery', *Savanna*, Vol. III, No. 1 (June), pp. 15–40.

Heathcote, David H. 1974. 'A Hausa charm gown', *Man*, New Series, Vol. IX, No. 4, pp. 620–624.

Heathcote, David H. 1974. 'Hausa embroidery stitches', *The Nigerian Field*, Vol. XXXIX, No. 4 (December), pp. 163–168.

Heathcote, David H. 1974. 'A leatherworker of Zaria City', *The Nigerian Field*, Vol. XXXIX, No. 1 (March), pp. 12–26; and Part II, *The Nigerian Field*, Vol. XXXIX, No. 3 (September), pp. 99–117.

Heathcote, David H. 1975. 'Hausa hand-embroidered caps', *The Nigerian Field*, Vol. XL, No. 2 (June), pp. 54–73.

Jaggar, P. J. 1973. 'A Kano blacksmith's vocabulary', *Kano Studies*, New Series, Vol. I, No. 1, pp. 99–109.

Jaggar, P. J. 1973. 'Kano City blacksmiths: precolonial distribution, structure and organisation', *Savanna*, Vol. II, No. 1 (June), pp. 11–25.

Kirk-Greene, Anthony H. M. 1961. 'Decorated houses in Zaria', *Nigeria Magazine*, No. 68 (March), pp. 53–78.

Kirk-Greene, Anthony H. M. 1963. *Decorated houses in a northern city*. Kaduna: Baraka Press.

Krieger, Kurt. 1961. 'Topferei der Hausa', *Beiträge zur Völkerforschung*, 11. Edited by D. Drost and W. König.

Krieger, Kurt. 1968. 'Musikinstrumente der Hausa', *Baessler-Archiv, Neue Folge*, Vol. XVI, pp. 373–429.

Mackay, M. 1949. 'Nigerian folk music instruments', *Nigeria Magazine*, No. 30, pp. 337–339.

Mackay, M. 1955. 'The *shantu* music of the *harims* of Nigeria', *African Music*, Vol. I, No. 2, pp. 56–57.

Meinhof, Carl. 1924. 'Ein magisches Quadrat auf einem Hausa-Amulett', *Zeitschrift für Eingeborenen Sprachen*, Vol. XIV, pp. 224–226, 315.

Moody, H. L. B. 1969. *The walls and gates of Kano City*. Lagos: Department of Antiquities.

Moughtin, J. C. 1964. 'The traditional settlements of the Hausa people', *The Town Planning Review*, Vol. XXXV, No. 1, pp. 21–34.

Moughtin, J. C. 1972. 'The Friday Mosque, Zaria City', *Savanna*, Vol. I, No. 2 (December), pp. 143–163.

Moughtin, J. C. and Leary, A. H. 1965. 'Hausa mud mosque', *Architectural Review*, No. 137, p. 156.

Nicholson, W. E. 1929. 'The potters of Sokoto, Northern Nigeria', *Man*, Vol. XXIX, pp. 45–50.

Richards, J. M. 1972. 'Kano and Zaria', *Architectural Review*, No. 906 (August), pp. 118–120.

Schwerdtfeger, Friedrich. 1971. 'Housing in Zaria', *Shelter in Africa*, ed. Paul Oliver. London: Barrie and Jenkins, pp. 58–79.

Vilee, James W. and Badejo, James. 1973. 'A preliminary study of '*Yan Lela Masu Ki'dan Buta*', *Studies in Nigerian culture*, Vol. I, No. 1. Kano, Centre for Nigerian Cultural Studies, pp. 52–109.

PUBLICATIONS PARTLY OR INDIRECTLY CONCERNED WITH THE ARTS OF THE HAUSA

Boas, Franz. 1927. *Primitive art*. Oslo: H. Aschehoug and Co., reprinted New York, Dover, 1955.

Boser-Sarivaxévanis, Renée. 1969. *Aperçus sur la teinture à l'indigo en Afrique Occidentale*. Basel: Naturforschende Gesellschaft, 80/I.

Boser-Sarivaxévanis, Renée. 1972. *Textilhandwerk in West-Afrika: Weberei und Farberei*. Basel: Museum für Völkerkunde und Schweizerisches Museum für Volkskunde.

Boser-Sarivaxévanis, Renée. 1972. *Les tissus de l'Afrique Occidentale*. Basel: Pharos-Verlag.

Bossert, Helmuth Theodor. 1964. *Folk art in Asia, Africa and the Americas.* New York: Praeger.

Bravmann, Réné A. 1974. *Islam and tribal art in West Africa.* London: Cambridge University Press.

Eicher, Joanne Bubolz. 1969. *African dress: a select and annotated bibliography.* Michigan: Michigan State University.

Fagg, Bernard E. B. 1956. 'The rock gong complex today and in prehistoric times', *Journal of the Historical Society of Nigeria*, Vol. I, No. 1, pp. 27–42.

Fagg, William Buller (ed.). 1971. *The living arts of Nigeria.* London: Studio Vista.

Farmer, H. G. 1939. 'Early references to music in the Western Sudan', *Journal of the Royal Asiatic Society*, pp. 569–580.

Frobenius, Leo. 1913. *The voice of Africa*, Vol. II. New York: Benjamin Blom, reprinted 1968.

Gabus, Jean. 1958. *Au Sahara: arts et symboles.* Neuchâtel: La Baconnière.

Gardi, René. 1969. *African crafts and craftsmen.* New York: Van Nostrand Reinhold.

Gardi, René. 1973. *Indigenous African architecture.* New York: Van Nostrand Reinhold.

Gaskin, L. P. J. 1965. *A bibliography of African art.* London: International African Institute.

Hause, H. E. 1948. 'Terms for musical instruments in the Sudanic languages: a lexicographical inquiry', *Journal of the American Oriental Society*, Vol. LXVIII, Supplement 7.

Jackson, George. 1967. 'Artificial rock hollows on Kuffena inselberg', *West African Archaeological Newsletter*, No. 6 (May), pp. 32–35.

Johansson, Sven-Olaf. 1967. *Nigerian currencies.* Sweden: printed by Alfa-Tryck, Skolgatan, Norrkoping.

Krieger, Kurt. 1963. 'Notizen zur Eisengewinnung der Hausa', *Zeitschrift für Ethnologie*, No. 88, pp. 318–331.

Lebeuf, Jean-Paul. 1970. 'Broderie et symbolisme chez les Kanouri et les Kotoko', *Objets et Mondes*, Vol. X, No. 4 (Winter), pp. 263–280.

Leiris, Michel, and Delange, Jacqueline. 1968. *African art*, trs. Michael Ross. London: Thames and Hudson.

Leith-Ross, Sylvia. 1970. *Nigerian pottery: a catalogue.* Ibadan: Ibadan University Press.

Lugard, Flora L. 1906. *A tropical dependency.* London.

Menzel, Brigitte. 1973–74. *Textilien aus Westafrika.* Berlin: Museum für Völkerkunde.

Mischlich, Adam. 1942. *Über die Kulturen im Mittel-Sudan: Landwirtschaft, Gewerbe, Handel.* Berlin: Dietrich Reimer.

Nigeria in costume. 1962. London: Shell Company of Nigeria.

Norris, M. W. and Perry, S. H. 1972. 'Terracotta figurines from near Zaria, Nigeria', *West African Journal of Archaeology*, Vol. II, pp. 103–107, pls. 3–7.

Pâques, V. 1953. 'L'estrade royale des Niaré'. *Bulletin de l'Institut Français d'Afrique Noir*, Vol. XV, No. 4, pp. 1642–1654.

Sieber, Roy. 1972. *African textiles and decorative arts.* New York: Museum of Modern Art.

Tilke, Max. 1956. *Costume patterns and designs: a survey of costume patterns and designs of all periods and nations from antiquity to modern times.* London: A. Zwemmer.

Trowell, Kathleen Margaret. 1960. *African design.* London: Faber.

Willett, Frank. 1971. *African art: an introduction.* London: Thames and Hudson.

OTHER ASPECTS OF HAUSALAND

Abubakar, Sa'ad. 1974. 'The emirate-type of government in the Sokoto caliphate', *Journal of the Historical Society of Nigeria*, Vol. VII, No. 2 (June), pp. 211–229.

Adeleye, R. A. 1974. 'The Sokoto Caliphate in the nineteenth century', *History of West Africa*, ed. J. F. A. Ajayi and M. Crowder, Vol. II. London: Longman, pp. 57–92.

Barth, Heinrich. 1857–58. *Travels and discoveries in North and Central Africa.* 5 vols. London: Longman, Brown, Green, Longmans and Roberts.

Boahen, A. Adu. 1964. *Britain, the Sahara, and the Western Sudan 1788–1861.* Oxford: Clarendon Press.

Bovill, E. W. 1970 (2nd ed.). *The golden trade of the Moors.* London: Oxford University Press.

Clapperton, Hugh. 1829. *Journal of a second expedition into the interior of Africa from the Bight of Benin to Soccatoo.* London: John Murray, reprinted Cass, 1966.

Cohen, Abner. 1969. *Custom and politics in urban Africa: a study of Hausa migrants in Yoruba towns.* London: Routledge and Kegan Paul.

Denham, Dixon; Clapperton, Hugh; and Oudney, Walter. 1826. *Narrative of travels and discoveries in Northern and Central Africa in the years 1822, 1823 and 1824.* 2 vols. London: John Murray.

Fletcher, R. S. 1912. *Hausa sayings and folk-lore: with a vocabulary of new words.* London: Oxford University Press.

Goody, Jack R. and Mustapha, T. M. 1967. 'The caravan trade from Kano to Salaga', *Journal of the Historical Society of Nigeria*, Vol. III, No. 4, pp. 611–616.

Greenberg, Joseph Harold. 1941. 'Some aspects of Negro-Mohammedan culture-contact among the Hausa', *American Anthropologist*, January-March, pp. 51–60.

Greenberg, Joseph Harold. 1946. *The influence of Islam on a Sudanese religion.* Monograph of the American Ethnological Society. New York: J. J. Augustin.

Greenberg, Joseph Harold. 1947. 'Islam and clan organisation among the Hausa', *Southwestern Journal of Anthropolgy*, Vol. III, pp. 193–211.

Hallam, W. K. R. 1966. 'The Bayajida legend in Hausa folklore', *Journal of African History*, Vol. VII, No. 1, pp. 47–60.

Hassan, Alhaji, and Na'ibi, Shuaibu. 1962. *A chronicle of Abuja.* Lagos: African Universities Press.

Hill, Polly. 1972. *Rural Hausa : a village and a setting.* Cambridge: Cambridge University Press.

Hiskett, Mervyn. 1964, 1965. 'The "Song of Bagauda": a Hausa king list and homily in verse'. I, II, III, *Bulletin of the School of Oriental and African Studies, University of London*, Vol. XXVII, pp. 540–567, Vol. XXVIII, pp. 112–135, Vol. XXVIII, pp. 363–385.

Hiskett, Mervyn. 1966. 'Materials relating to the cowry currency of the Western Sudan – I, A late nineteenth century schedule of inheritance from Kano; II, Reflections on the provenance and diffusion of the cowry in the Sahara and the Sudan', *Bulletin of the School of Oriental and African Studies, University of London*, Vol. XXIX, pp. 122–142, 339–366.

Hogben, S. J. and Kirk-Greene, A. H. M. 1966. *The emirates of Northern Nigeria: a preliminary survey of their historical traditions.* London: Oxford University Press.

Hopkins, A. G. 1973. *An economic history of West Africa.* London: Longman.

Hunwick, John O. 1971. 'Songhay, Bornu and Hausaland in the sixteenth century', *History of West Africa*, ed. J. F. A. Ajayi and M. Crowder, Vol. I, pp. 202–239. London: Longman.

Johnson, Marion. 1970. 'The cowrie currencies of West Africa' – Part I, *Journal of African History*, Vol. XI, No. 1, pp. 17–49; Part II, Vol. XI, No. 3, pp. 331–353.

Johnson, H. A. S. 1966. *A selection of Hausa stories.* London: Clarendon Press.

Johnson, H. A. S. 1967. *The Fulani empire of Sokoto.* London: Oxford University Press.

Kirk-Greene, Anthony H. M. 1960. 'The major currencies in Nigerian history', *Journal of the Historical Society of Nigeria*, Vol. II, No. 1 (December), pp. 132–150.

Kirk-Greene, Anthony H. M. (ed.). 1971. *Gazeteers of the Northern Provinces of Nigeria.* Reprinted in 4 vols. London: Cass.

Kirk-Greene, Anthony H. M. 1974. *Mutumin kirkii: the concept of the good man in Hausa.* Indiana: Indiana University Press.

Krieger, Kurt. 1959. *Geschichte von Zamfara : Sokoto-Provinz, Nordnigeria.* Berlin: Dietrich Reimer Verlag.

Krieger, Kurt, 1964. 'Weitere Bemerkungen zur Geschichte von Zamfara, Sokoto-Provinz, Nordnigeria', *Baessler-Archiv, Neue Folge,* Vol. XII, pp. 89–139.

Krieger, Kurt. 1967. 'Notizen zur Religion der Hausa', *Paideuma* 13, pp. 96–121.

Larymore, Constance. 1908. *A resident's wife in Nigeria.* London: Routledge.

Last, D. Murray. 1967. 'A note on attitudes to the supernatural in the Sokoto jihad', *Journal of the Historical Society of Nigeria,* Vol. IV, No. 1 (December), pp. 3–13.

Last, D. Murray. 1967. *The Sokoto Caliphate.* London: Longman.

Last, D. Murray. 1974. 'Reform in West Africa: the jihad movements of the nineteenth century', *History of West Africa,* ed. J. F. A. Ajayi and M. Crowder, Vol. II, pp. 1–29. London: Longman.

Last, D. Murray and Al-Hajj, M. A. 1965. 'Attempts at defining a Muslim in 19th century Hausaland and Bornu', *Journal of the Historical Society of Nigeria,* Vol. III, No. 2 (December), pp. 231–248.

Leggett, Jack. 1969. 'Former hill and inselberg settlements in the Zaria district', *West African Archaeological Newsletter,* No. 11 (March), pp. 26–34.

Lewis, I. M. (ed.). 1966. *Islam in tropical Africa.* London: International African Institute, Oxford University Press.

Low, Victor Nelson. 1972. *Three Nigerian emirates : a study in oral traditions.* Evanston: Northwestern University Press.

Meek, C. K. 1925. *The northern tribes of Nigeria.* 2 vols. London: reprinted Cass, 1971.

Miller, Walter R. S. 1936. *Reflections of a pioneer.* London: C.M.S.

Monteil, Vincent. 1964. *L'Islam noir.* Paris: Seuil.

Mortimore, M. J. 1970. 'Settlement evolution and land use', *Zaria and its region,* ed. M. J. Mortimore. Zaria: Ahmadu Bello University, Department of Geography Occasional Paper No. 4, pp. 102–122.

Mortimore, M. J. and Wilson, J. 1965. *Land and people in the Kano close-settled zone.* Zaria: Ahmadu Bello University, Department of Geography Occasional Paper No. 1.

Nachtigal, Gustav. 1879, 1881, 1889. *Sahara und Sudan : Ergebnisse sechsjahriger Reisen in Afrika 1879–1889.* 3 parts: I, Berlin; II, Berlin; III, Leipzig.

Nadel, S. F. 1942. *A black Byzantium : the kingdom of the Nupe in Nigeria.* London: International African Institute, Oxford University Press.

Obayemi, Ade M. U. 1973. 'Aspects of field archaeology in Hausaland', *Studies in Nigerian culture,* Vol. I, No. 1, pp. 4–25. Kano: Centre for Nigerian Cultural Studies.

Paden, John N. 1970. 'Urban pluralism, integration and adaptation of communal identity in Kano, Nigeria', *From tribe to nation in Africa: studies in incorporation processes*, ed. by R. Cohen and J. Middleton. Pennsylvania: Chandler, Seranton.

Paden, John N. 1973. *Religion and political culture in Kano*. Berkeley and London: University of California Press.

Palmer, Herbert. 1908. 'The Kano chronicle', *The Journal of the Royal Anthropological Institute*, Vol. XXXVIII, pp. 58–98, pls. 9 and 10.

Palmer, Herbert. 1928. *Sudanese memoirs*. 3 vols. Lagos: Government Printer.

Perham, Margery Freda (ed.). 1956–58. *The economies of a tropical dependency*. 2 vols. Vol. I, C. D. Forde and R. Scott, *The native economies of Nigeria*. London: Faber.

Pullan, R. A. 1974. 'Farmed parkland in West Africa', *Savanna*, Vol. III, No. 2 (December), pp. 119–151.

Rattray, Robert S. 1913. *Hausa folk-lore, customs, proverbs, etc.* London: Oxford University Press.

Robinson, Charles Henry. 1896. *Hausaland; or fifteen hundred miles through the Central Sudan*. London.

Robinson, Charles Henry. 1900. *Nigeria; our latest protectorate*. London: Horace Marshall and Son.

Shaw, Thurstan. 1971. 'The prehistory of West Africa', *History of West Africa*, ed. J. F. A. Ajayi and M. Crowder, Vol. I, pp. 33–77. London: Longman.

Skinner, Neil. 1968. 'The origin of the name *Hausa*', *Africa, Journal of the International African Institute*, Vol. XXXVIII, No. 3 (July), pp. 253–257.

Smith, Abdullahi. 1970. 'Some considerations relating to the formation of states in Hausaland', *Journal of the Historical Society of Nigeria*, Vol. V, No. 3, pp. 329–346.

Smith, Abdullahi. 1970. 'Some notes on the history of Zazzau under the Hausa kings', *Zaria and its region*, ed. M. J. Mortimore. Zaria: Ahmadu Bello University, Department of Geography Occasional Paper No. 4, pp. 82–101.

Smith, Abdullahi. 1971. 'The early states of the Central Sudan', *History of West Africa*, ed. J. F. A. Ajayi and M. Crowder, Vol. I, pp. 158–201. London: Longman.

Smith, Mary. 1954. *Baba of Karo: a woman of the Muslim Hausa*. London: Faber.

Smith, Michael G. 1954. Introduction to Mary Smith, *Baba of Karo*. London: Faber.

Smith, Michael G. 1955. *The economy of the Hausa communities of Zaria*. London: Colonial Research Series No. 16, Her Majesty's Stationery Office, reprinted Gregg.

Smith, Michael G. 1957. 'The social functions and meaning of Hausa praise-singing', *Africa, Journal of the International African Institute*, Vol. XXVII, pp. 26–45.

Smith, Michael G. 1960. *Government in Zazzau, 1800–1950*. London: International African Institute, Oxford University Press.

Smith, Michael G. 1962. 'Exchange and marketing among the Hausa', *Markets in Africa*, ed. P. Bohannen and G. Dalton. Evanston: Northwestern University Press.

Smith, Michael G. 1966. 'The Hausa of Northern Nigeria', *Peoples of Africa*, ed. J. L. Gibbs, pp. 119–155. New York: Rinehart and Winston.

Staudinger, Paul. 1889. *Im Herzen der Haussaländer*. Berlin: A. Landsberger.

Tremearne, A. J. N. 1913. *Hausa superstitions and customs: an introduction to the folk-lore and the folk*. London: John Bale and Danielsson.

Tremearne, A. J. N. 1914. *The ban of the bori*. London: reprinted Cass, 1968.

DICTIONARIES

Abraham, Roy Clive. 1946. *Dictionary of the Hausa language*. London: University of London Press.

Bargery, G. P. 1934. *A Hausa-English dictionary and English-Hausa vocabulary*. Oxford: Oxford University Press.

Robinson, Charles Henry. 1925. *Dictionary of the Hausa language*. 2 vols: Vol. I, *Hausa-English*, Vol. II, *English-Hausa*. London: Cambridge University Press, 1899–1900; 4th edition, London: Cambridge University Press.

RECORDED MUSIC

Ames, David W. 1968. *An anthology of African music: the music of Nigeria, Hausa music*. Records I and II. Bahrenreiter Musicaphon BM 30 L 2306 and BM 30 L 2307. UNESCO collection.

English–Hausa Vocabulary

The following should be used in conjunction with a Hausa dictionary, such as Bargery's or Abraham's. The Hausa hooked letters are indicated by 'b, 'd, and k'.

adornment, *ado*
adze, *gizago*
amulet, *laya* (written)
ankle-bands (of trousers), *k'afa*
antimony, *kwalli*
anvil, *uwar mak'era*
apron, *warki*; *bami* (embroidered leather)
Arabic writing, *rubutun Arabe*
arch (roof), *baka*
artist, *mai zane* (decorator, e.g. of calabashes)
ashes, *toka*
awl, *kibiya*
axe, *gatari*

back stitch, *basi'da*
bag, *jaka* (leather)
ball of indigo, *tunkulen shuni*
ball of ink powder, *tunkulen tawada*
bangle-charm, *kambu*
baobab tree, *kuka*
barber, *wanzami*
basket, *adudu* (with lid); *kwando*
basin, *kwano* (metal)
beads (prayer), *karamba*
beat, *buga* (instead of ironing); *san'diya* (making cloth glossy)
beater, *akwasa* (the wooden stick used by women in weaving)
beauty, *zina*
bed, *gado*
bed cover (embroidered), *zanen gado*
bell, *gwarje* (on horse or donkey)
bellows, *zugazugi*
belt, *'damara*; *guru* (tubular, of leather or cloth)
big gown, *babbar riga*
black, *bak'i*
blacksmith, *mak'eri*
blanket, *gwado*; *bargo*

blouse, *taguwar mata* (woman's); *riga, rigan 'yam mata* (girl's)
blue, *shu'di*; *bak'i* (very dark, almost black)
boat, *jirgi*
body decoration, *shasshawa*
book, *littafi*
book cover, *tadarishi* (stiff, for holding collection of separate sheets, e.g., copy of the Qur'ān)
bow, *baka* (of musical instrument, or archer's, or for preparing cotton for spinning)
bowl, *kwano* (metal)
box, for loose papers, *gidan tadarishi*; *gidan Dala'ilu* (small)
bracelet, *abin hannu*; *warwaro*
brick, *tubali* (made of dried mud and pear shaped)
broker, *dillali*
builder, *magini*
building clay (mud), *laka*
burnous, *alkyabba*
buttonhole stitch, *zargo*

caftan, *kaftani*
calabash, *buta* (small water-container); *gora* (large, used as float for person on water); *kurtu* (small); *k'urzunu* (type of warty gourd); *k'warya* (circular); *ludayi* (spoon-shaped); *masaki* (very large); *shantu* (aerophone: musical instrument); *zunguru* (for dyeing hands with henna)
calabash-mender, *gyartai*
calabash-stand (a leather-covered ring), *tarde*
canoe, *kwale-kwale* (of wood); *jirgi*
cap, *hula*; *k'ube* (decorated with many small patches of coloured embroidery); *tagiya*
carrier's headpad, *gammo*
cement, *laso, katsi* (local cement)
chain, *sark'a* (also used to describe an interlacing pattern)
chain armour, *sulke*
chain stitch, *surfani*
charm, *laya* (written)
charm case, *rufin laya*
charm gown, *rigar layu*
chief, *sarki*
city, *birni* (walled)

clay, *laka* (for building); *yum'bu* (for pottery); *farin k'asa* (white, used for whitewash and the exterior of certain calabashes)
cloth, *zane* (woman's wrapper)
clothes, *tufafi*
coiffure (woman's), *kitso*
colour, *launi*
comb, *matsefi*
compasses, *bukari*
compound, *gida* (house)
cooler, *kwala* (for water)
coral, *murjani* (red)
cornstalk, *kara*
cotton, *auduga*
cotton thread, *abawa* (loosely hand-spun); *zare*
couching, *'dunke* (i.e. a type of embroidery stitching)
cowrie shell, *wuri*
crow, *hankaka* (two-toned, indigo-dyed gown)
cushion, *matashin kai*
cylindrical drum, *ganga*, etc. (*See under* drum)

decoration, *ado*
decorator, *mai zane*
deleb-palm, *giginya*
design, *zane*
dish, *tasa*
doll, *'yar tsana*
door lock, *kuba* (of iron)
double-handed scraper, *kartaji* (used in the preparation of leather)
draughtsman, *mai shaida* (who draws out embroidery designs on cloth)
draw, or ornament (*verb*), *zana*
drawing (on woman's wrapper preparatory to embroidery), *zanen zane*
drum, *ganga* (cylindrical farm drum); *k'alangu* (hour-glass-shaped drum); *tambari*, *taushi* (kettle drum)
drummer, *mai k'alangu* (plays an hour-glass-shaped drum); *maka'di*
drum stick, *maka'di*
dry season, *rani*
dum-palm, *kaba*; *goruba*
dye, *rina* (dyed with indigo); *shu'di* (act of dyeing blue); *shuni* (indigo, from the plant called *baba*)
dye pit, *karofi*
dyer, *marini*

east, *gabas*
Egyptian mimosa, *bagaruwa*
eight knives, *aska takwas* (embroidery design)
embroiderer, *ma'dinki*
embroidery, *'dinke*; *'dinkin hannu* (hand embroidery); *'dinkin keke* (machine embroidery)
entrance hut, *zaure*
expert, *gwani* (m.)
eye, *ido*

face ornament, *'dan goshi* (for horse)
family compound, *gida*
fan, *figini*; *mafici*
farm, *gona*
fez, *dara*
fiddle, *goge*
file, *zarto*
fire, *wuta*
fish, *kifi*
fly stitch, *kwan fara*
food bowl, *akushi* (of wood)
forge, *mak'era*
fringe, *baza* (e.g. of leather)
Fulani gown, *rigan Filani*

gate, *k'ofa*
gold, *zinariya*
goldsmith, *makerim farfaru*
gong, *kuge* (of metal)
gown, *riga*
green, *algashi*; *kore*
groundnut, *gya'da*
groundnut paste, *tunkuza* (after oil has been extracted)
guinea corn, *dawa*
gun, *bindiga*
gusset, *shige*

halter, *ragama*; *gumik'a* (ornamented with metal)
hammer, *hama* (large, metal, etc.)
hand, *hannu*
handle, *k'ota* (e.g. of hoe); *'bota* (haft)
handsome, *da kyau*
hat, *malfa* (straw); *hula* (cap)
Hausa person, *Bahaushe*; *Ka'do* (original inhabitants of Hausaland)
hemp (Indian), *rama*; *kyankyalashe*
henna, *lalle*
herringbone stitch, *fitsarim bijimi*; *k'ayan kifi*
hide, *fata* (skin)
hip girdle, *jigida* (worn under the clothes)
history, *tarihi* (written)
hoe, *garma* (large): *fartanya* (small)
horn, *k'aho*
horse, *doki*
horse trappings, *kayan doki*
hour-glass-shaped drum, *k'alangu*
house, *gida*
hut, *'daki*

imam, *liman*
Indian hemp, *rama*; *kyankyalashe*
indigo, *shuni*; *baba* (plant)
ink, *tawada*; *tunkulen tawada* (ball of dry ink)
ink pot, *kurtun tawada*
interlacing pattern, *sark'a*; *dagi*
iron, *k'arfe*

iron ore, *tama*
ivory, *hak'orin giwa*

jewelry, *abin ado*
Jew's harp, *bambaro*

Kano person, *Bakane*
kapok, *audugar rimi*
kerchief, *fatala*
kettle drum, *taushi*; *tambari*
king, *sarki*
knife, *wuk'a*; *aska*; *wuk'an makera*
'knot' design, *dagi* (decorative motif of two interlaced
 ovals)
kolanut, *goro*

ladle, *ludayi* (made from small gourd)
lamp, *fitila*
leather, *fata*
leather-worker, *baduku*
little, *k'arami*
locust bean tree, *dorawa*
loincloth, *bante*
looking-glass, *madubi*
loom, *masak'a*
loom heddles, *andira*
lute, *garaya*; *komo*; etc.

mallet, *'dam bugu* (used by cloth beaters)
man, *mutum*
market, *kasuwa*
market stall, *rumfa*
marriage, *aure*
mat, *tabarme*; *faifai* (small and circular, of coiled
 basketry)
matchet, *adda*
medicine, *magani*
metal, *k'arfe*
mica, *da'da kyau* (used in wall decoration)
milk, *madara* (fresh); *nono* (sour)
minaret, *hasumiya*
mirror, *madubi* (looking-glass)
mirror case, *gidan madubi*
mister (Mr.), *Malam* (also teacher, or advanced
 scholar of Arabic)
money, *ku'di*
money belt, *gurun ku'di*
mortar, *turmi* (for pounding grain)
Muslim, *Musulmi* (m.); *Musulma* (f.)
mosque, *masallaci*
mouth, *baki*

neck, *wuya*
necklace, *abin wuya*

needle, *allura*
needle case, *ma'alufi*; *gidan allura*
needleweaving, *tatunashi*
new, *sabo*
north, *arewa*

oil, *mai*
old, *tsoho*
open chain stitch, *kwashe*
ostrich, *jimina*

palace, *gidan sarki*; *fada*
paper, *takarda*
parchment-work vessel, *tandu*
pattern, *launi*
patterning tool, *mazani*
peddler, *'dan koli* (of small wares, e.g. haberdashery)
pen, *alkalami*
pen case, *korami*
pencil, *fensir*
pestle, *ta'barya*
pilgrim (after return from Mecca), *alhaji* (m.);
 alhajiya (f.)
pilgrimage (to Mecca), *haji*
pillow, *matashin kai* (leather)
pincers, *bincin*
pipe, *lofe*; *tukunyan taba* (made of pottery)
pitcher, *tulu* (spherical, with small mouth)
pocket, *aljihu*
pole, *muciya* (for stirring dye in dye-pit)
pommel cover, *hulan sirdi*
porridge, *tuwo*
pot, *fitila* (lamp); *kwala* (cooler); *murhu* (stove
 brazier); *randa* (for storing water); *tukunya* (cooking);
 tulu (spherical, for carrying water)
potash, *kanwa*
potter, *magini*
pottery clay, *yum'bu*
pottery coin 'bank', *banki*
pounding, *lugude* (of several women at a mortar, or
 smiths at an anvil)
praise singer, *marok'i* (m.); *marok'iya* (f.)
prayer beads, *karamba*
privet, *lalle* (i.e. Egyptian, = henna)
punches, *'yan zane* (for decorating leather)
purse, *alabe* (double); *tsuttsuki* (with draw string);
 alabe na rataya (for hanging on shoulder)
pyro-engraving, *zanen wuta*

Qur'ān, *Alkuran*
Quranic decoration, *zayyana* (for the Qur'ān, writing
 boards, etc.)
Quranic writing board, *allo*

rainy season, *damina*
raphia palm, *tukurwa*
razor, *aska*
razor case, *gidan aska*; *tankolo* (cylindrical)
read, *karanta*
red, *ja*
red dye, *karan dafi* (from a type of sorghum)
red ink, *koya*
reed wind-instrument, *algaita* (shawm)
reins, *kamazuru*
repair (*verb*), *gyara*
riding boots, *safa*
ring, *zobe*
road, *hanya*
rocky outcrop, *dutse*
roof, *jinka* (thatch); *soro* (clay)
room, *'daki*; *soro* (mud-walled and mud-roofed)
root fibre, *me'di* (of dum-palm)
rope, *igiya*
rosary, *karamba* (of wooden beads)
running stitch, *laflaftu*

saddle, *sirdi*
saddle cloth, *jalala* (embroidered)
saddle cover, *rigan sirdi*
sandal, *takalmi*
satchel, *gafaka* (for Qur'ān)
saw, *zarto* (tool)
school, *makaranta*; *makarantar Alkuran* (Quranic)
scissors, *almakashi*
scissors-case, *gidan almakashi*
sell, *sayar*
sew, *'dinka*
sewing machine, *keken 'dinki*
shawm, *algaita*
sheath, *kube*
shoe, *takalmi*
shoulder purse, *alabe na rataya*
shuttle, *k'oshiya*
sieve, *rariya*
silk, *tsamiya* (wild); *alharini* (imported silk or silky thread)
silk-cotton tree, *rimi*
silver, *azurfa*
silversmith, *makerim farfaru*
singer, *mawak'i* (m.); *mawak'iya* (f.)
skill, *gwaninta*
skin, *fata*
slave, *bawa*
small gown, *'yar ciki* (of strips, often worn as under-gown); *gambari*
snake, *maciji*
spear, *mashi*
spindle, *mazari*; *tangori* (large)
spindle whorl, *gululu* (of clay)
spinning, *ka'di*
spool, *matari*

spoon, *cokali*
stairs, *matakai*
stem stitch, *fishi*
stirrup, *likkafa*
stone (*noun*), *dutse*
stool, *kujera*
stove, *murhu* (of stone or pottery)
strap, *maratayi* (for hanging anything up)
straw hat, *malfa*
suet, *kitsen bijimi*
sword, *takobi*
sword sling, *hamila*

tailor, *ma'dinki*
tall, *dogo*
tamarind, *tsamiya*
tanner, *majemi*
tannery, *majema*
tanning, *jema*
tassel, *tuntu*; *tuta*
tattoo marks, *jarfa*; *shasshawa*; *akanza* (below the temples; *'yan wuya* (on the neck)
teacher, *Malam* (Quranic)
tease, *ka'da* (of cotton)
tenth of a penny, *anini*
thimble, *safi*; *safi na 'dinki*
thousand stitches, *suka dubu* (type of embroidery on saddle cloth)
thread, *zare*
tie-and-dye, *adire*
tin, *garwa*
tinder bag, *jakan alhawami*
tinsel thread, *asiliki*
tobacco, *taba*
tongs, *hantsaki*
tool, *mazani* (for decorating)
tools, *kayan aiki*
torque bangle, *munduwa*
town, *gari*
trade, *sana'a*
tray, *faifai* (of coiled basketry)
tree, *itace*
triangular-shaped amulet, *alwatikan laya*
tribal marks, *shasshawa*
trousers, *wando*
trouser-string, *mazagi*
trumpet, *kakaki* (long, metal)
turban, *rawani*
tweezers, *matsefata*
tweezers case, *gidan matsefata*
two knives, *aska biyu* (embroidery design)
two needles, *allura biyu* (brightly coloured embroidery design on gowns)

under-gown, *'yar ciki* (small, made of strips)

village, *k'auye*

wall, *bango*
wall decoration, *zanen gida* (exterior)
wallet, *zabira*
warp threads, *doki*
wash (*verb*), *wanke* (clothes, pots, etc.)
water, *ruwa*
water jug, *buta* (pottery); *shantali* (metal)
wave stitch, *k'ayan kifi*; *fitsarim bijimi*; *tafiyan tana*
weave (*verb*), *sak'a*
weaver, *masak'i*
weaving place, *masak'a*
weft, *abawa*
wet season, *damina*
white, *fari*
white clay, *farin k'asa*

wild silk, *tsamiya*
window, *taga*
wire, *waya*
wire basket, *ruzu*; *kwandon waya*
woman, *mace*
wood, *itace*
woodcarver, *masassak'i*
wool, *ulu*
work, *aiki*
wrapper, *zane* (woman's cloth)
write (*verb*), *rubuta*
writing board, *allo*

yellow, *rawaya*